Becoming a

Theory Redux

Series editor: Laurent de Sutter

Becoming an Artwork

Boris Groys

polity

First published in 2023 by Polity Press

Polity Press
65 Bridge Street
Cambridge CB2 1UR, UK

Polity Press
111 River Street
Hoboken, NJ 07030, USA

ISBN-13: 978-1-5095-5196-5
ISBN-13: 978-1-5095-5197-2 (pb)

A catalogue record for this book is available from the British Library.

Library of Congress Control Number: 2022935232

Typeset in 12.5 on 15 pt Adobe Garamond
by Cheshire Typesetting Ltd, Cuddington, Cheshire
Printed and bound in Great Britain by CPI Group (UK) Ltd, Croydon

For further information on Polity, visit our website:
politybooks.com

I

Our culture is often described as narcissistic. And often enough narcissism is understood as total concentration on oneself, and lack of interest in others, in society. However, the mythological Narcissus is not interested in the pursuit of his desires or contemplation of his inner visions but in the image that he offers to the world. And the image of our bodies is external to us. We cannot see our own face or our body in its entirety. Our image belongs to others, to the society in which we live. The moment Narcissus looks into the lake, he joins society, rejects his own "subjective" perspective – and for the first time looks at himself from the outside position, sees himself as others see him. Narcissus is enchanted by his own

image as an "objective" image that is produced by Nature and is equally accessible to everybody.

Narcissism means understanding one's own body as an object, as a thing in the world – similar to every other thing. In our post-religious, secular epoch, humans are no longer considered to be containers filled by spirit, reason, or soul, but as living bodies. But one can speak about a body in at least two different ways. The body can be understood as living flesh that manifests itself through different kinds of desire: hunger, thirst, sexual desire, "cosmic feeling," etc. Here, the difference between spirit and flesh, or thinking and desire, is not so big as it often seems to be. In the first case, one experiences evidence by solving mathematical problems; in the second case, one experiences the intensity of desire. But in both cases, one remains within the "inner world" of subjective feelings and thoughts.

The body can be discovered, though, not merely "from within" through the desires of the flesh, but also from the external, social, public perspective. From this external perspective, life does not manifest itself in the body as energy or desire, but is established by means of medical examination. The narcissistic desire is desire to

appropriate this public perspective on one's own body – to look at oneself through the gaze of others. Or, in other words, it is a desire to bridge the gap between the inner experience of the body as living flesh and the public view of the same body as a particular thing, an object in the world.

In our culture, the objectivation of the body by the gaze of others has a bad reputation because the object seems to take a lower position in the value hierarchy compared to the subject. That is why Jean-Paul Sartre famously said that Hell is other people – *their gaze* makes us mere objects. The object is mostly understood as a tool; the objectification of humans means subjecting them to use by others as tools. However, Narcissus does not offer himself up for any use – including the sexual one. Thus, he rejects the seduction by nymph Echo. His "no" means "no," indeed – and the poor nymph loses her body as a result of disappointment. The image of Narcissus in the lake also cannot be used in any way. It can only be looked at. And Narcissus himself becomes identical to his reflection. One can say that Narcissus' "inner world" becomes a lake – thoughtless, desireless, quiet. There is nothing hidden behind Narcissus' face: you see what you

see. Narcissus sacrificed his inner world for his external image, which is accessible to everybody. At the moment at which Narcissus saw his image in the lake, he rejected all worldly seductions and all the chances and rewards of practical life in favor of pure contemplation. In this respect, the difference between narcissistic contemplation of one's own image and Platonic contemplation of the eternal light of the Good is not so big.

However, there is also a difference between these two scenes of contemplation. In the parabola of the cave, Plato describes a philosopher who leaves the cave of human society and contemplates the eternal light alone, unseen by others. On the contrary, Narcissus immerses himself in contemplation of his image in the middle of nature – potentially visible to others. Narcissus is like a living dead – still living but already dead, turning himself into an image, reduced to a pure form. That does not mean that Narcissus chose death over life. He contemplates his reflection in the lake in a state of self-oblivion that no longer differentiates between life and death. Narcissus does not want death – but nor does he want to prevent its coming. Narcissism is the opposite of self-preservation, of self-care. It produces

the body as undead form that exists only in the public eye.

In his essay about the mirror stage, Jacques Lacan describes the encounter of a child with its image in the mirror as a pre-social event, "in which the *I* is precipitated in a primordial form, prior to being objectified in the dialectic of identification with the other, and before the language restores to it, in the universal, its function as subject."[1] Communication with others begins, according to Lacan, with language. However, this understanding of the self-image as pre-social and pre-communicative is an effect of the specific regime of communication that dominated before the emergence of contemporary visual culture and, especially, the Internet. Today, children can make and distribute their selfies before they begin to speak. There are two possible reactions to these selfies that are expected from the public: liking or disliking.

Narcissus' image in the lake is an early form of selfie. Having been a member of the Greek cultural community, Narcissus obviously knew that he shared with other Greeks the same aesthetic taste. We are unable to like ourselves unless we assume that we are liked by the society in which

we live. But does it mean that Narcissus was liked by Greek society and by himself because he had this particular body or, to quote Lacan, this particular *I*? Not at all. He was liked because he was beautiful. But being beautiful is not a specific individual or even human characteristic. Beauty is transhuman. Not accidentally, after his death Narcissus was reborn as a flower. A flower has a different chemical and biological structure than a human body. The only common trait that allows us to compare Narcissus and a flower is that both are beautiful. And being beautiful means being a pure form, being not subjected to any suspicion concerning a dark, invisible space behind this form – not having any *I*.

Indeed, human bodies serve the goal of recognition and identification of humans in the public space, and also as coverage and protection of their "inner world" of desires, thoughts, and plans from the gaze of others. The human body creates a dark space of flesh isolated from the space of public visibility and identification. For society, this dark space becomes an object of suspicion and anxiety. It is what we call "soul," or "subjectivity." Subjectivity is nothing but a possibility to conceal and to lie. Looking at our face,

others cannot "read it" with certainty, cannot be sure that it manifests our thoughts and emotions. Every face is, to a certain degree, a poker face. Others do not have immediate access to what we think, how we feel – and that puts extremely uncomfortable social pressure on us. We are expected to explain ourselves, but the process of self-explanation has no end. In a very spectacular manner, Narcissus sacrificed his interests and desires to become a pure form beyond suspicion – to empty this form from any "content," from the soul, from the dark "inner world." Narcissus bridges the gap between his flesh and his public form not only by contemplating the reflection of his body that is equally accessible to everybody, but also by demonstrating ascetic concentration on this process of contemplation. The spectator cannot any more assume that there is a lie, conspiracy, strategy, and calculation hidden behind the surface of a body. The ecstatic body of contemplation offers an image of a totally socialized, "delivered," defenseless Self.

In the Christian tradition, this act of self-emptying is called *kenosis*. The perfect image of *kenosis* is the image of Christ on the cross. Here Christ becomes a pure image because we believe

that He has emptied himself of all "subjective" desires and interests. Now, how can we differentiate between Christ and Narcissus? How can we differentiate between sacrifice in the name of total self-socialization and sacrifice in the name of self-divinization? The human gaze cannot see this difference – only the divine one. But if God is dead, only the desire of admiration by others, by society, remains. Both Christ and Narcissus became superstars. In the past when we have spoken about the Other, we meant God or maybe Satan because they had an ability to see through our bodies and identify our souls as righteous or sinful. But now the Other became others – the society that sees only our bodies and not our souls. The ethical attitude is substituted by the aesthetic and the erotic. Society is interested not in our souls but in our public image. Our civilization is, indeed, narcissistic because it only values *kenosis* in the name of the public image – of public recognition and admiration.

In his course of lectures given at *l'École des hautes études* in Paris from 1933 to 1939, under the title *Introduction to the Reading of Hegel*, Alexandre Kojève speaks about the desire for admiration by others as *anthropogenic* desire; owing to this desire,

humans become humans. According to Kojève, we can speak of desire of the first and the second order. First-order desire signals to us our existence in the world. It is quite a reversal of the standard understanding of the word "desire." Usually, desire is interpreted as leading to attachment to things of this world. That is why, since Plato, philosophy and religion have tried to isolate the human soul from corporeal desires and direct it toward the contemplation of eternal ideas or God. However, today we are attached to the world not primarily through desires but through science. Modern contemplation is scientific contemplation of the world and everyday contemplation of the media – and not of an Idea or God. For us, it is therefore not the rejection of desires that opens the way to self-consciousness, but, on the contrary, the emergence of desires. Kojève writes:

> The man who contemplates is "absorbed" by what he contemplates; the "knowing subject" "loses" himself in the object that is known . . . The man who is "absorbed" by the object that he is contemplating can be "brought back to himself" only by a Desire; by the desire to eat, for example . . . The (human) I is the I of . . . Desire.[2]

Desire turns one from contemplation to action. This action is always "negation." The I of Desire is emptiness that consumes, negates, and destroys everything "external," "given": to satisfy hunger, one consumes food; to satisfy thirst, one consumes water.

But desire of the first order produces only self-sentiment and not yet self-consciousness. Self-consciousness is produced by a specific type of desire – the "anthropogenic" desire that is desire not of particular things but of the desire of the other: "Thus, in the relationship between man and woman, for example, Desire is human only if the one desires, not the body, but the Desire of the other."[3] Here, desire becomes dialectical. Anthropogenic desire is the negation of animal desire of the first order – the negation of negation. It does not destroy the other because it needs recognition by the other. It is this anthropogenic desire that initiates and moves history: "human history is the history of desired Desires . . . Self-Consciousness, the human reality . . . is, finally, a function of Desire for 'recognition'."[4] Humans are ready to risk their lives and even to sacrifice them for recognition and admiration by society. The history of wars and revolutions certify that.

We can see here the beginnings of the contemporary politic of identity that is basically a struggle for recognition. Bourgeois society and culture recognize individuals for what they achieved in terms of wealth or social position. In earlier, feudal culture, individuals were recognized by their origin, their genealogy, their identity – independently of their personal achievements. Contemporary identity politics is the democratization of the feudal, aristocratic ethos: everyone has an identity, an origin, and a genealogy that have to be respected. Everybody has a body that he or she wants to be recognized, accepted, liked by society. But the desire for recognition becomes often enough frustrated. Narcissus saw himself in the lake – and recognized himself as beautiful. But what happens when we see our reflection in a lake and come to a conclusion that – according to the dominating social conventions – we do not look beautiful? Then, the desire for recognition leads to a struggle for recognition. We struggle to change our body or to adapt it to the dominant conventions. Or we struggle against these conventions to make society recognize us as we are. Contemporary narcissism is not a passive contemplation of one's own body, but the

active, often violent, struggle for social recognition of this body as beautiful, respected, valued. Not accidentally, the popular imagination of our time is totally captured by the feudal culture with its struggles for recognition: from *Star Wars* to *Game of Thrones* and *Harry Potter*.

2

The narcissistic struggle for recognition is not only a struggle against social conventions but also a struggle against the desires of the flesh. The public image is recognized if it presents itself as a pure form – if it does not suggest a dark space of private interests, needs, and desires behind its surface. Otherwise the public image is perceived as being merely a camouflage – a means for achieving the hidden private goals.

In his essay on the notion of the gift, Marcel Mauss develops a theory of the symbolic exchange.[5] According to this theory, individuals acquire social recognition not because of their wealth, but because of their readiness to lose what they have – through gifts, charity, and, more

generally, sacrifices for the common good as well as wasteful consumption, excessive festivals, and wars. To acquire a symbolic value, one has to demonstrate that one does not want anything beyond social recognition and prestige. One can say that narcissism is irrational because it contradicts the rational strategies of self-preservation and success that we associate with reasonable behavior. Indeed, reason is nothing other than manifestation of the fear of death. In our eyes, individuals are reasonable when they avoid risky situations that could lead to death and when they take decisions that improve their chances of survival. In *Phenomenology of the Spirit*, Hegel writes that, at the end of history – which he associated with the French Revolution – humans recognized death as humanity's only and absolute Master.[6] Thus, after the French Revolution, Europeans became reasonable – engaged in accumulating capital and building administrative careers.

Seen from this perspective Narcissus is unreasonable: he is so immersed in contemplation of his image in the lake that he loses the self-sentiment of which Kojève has spoken and dies of exhaustion. When we speak about the irrational,

we mostly mean drives and desires that move people toward adventures, conflicts, and confrontations. We speak about energy and speed, about *élan vital*, about Nietzsche, Freud, and Bataille. But contemplation is no less dangerous and in this sense irrational. When I contemplate, I forget my needs, disregard my environment, and my body becomes unprotected. Reading a book or contemplating an image, I lose opportunities and overlook the dangers. The same is true when I am "thinking" about something that has no direct relationship to the goal of self-protection. In this case, reason is not transgressed but simply ignored. Contemplation is immersion into an object of contemplation that leads to self-oblivion. This object can be platonic eternal ideas. It can be God. But it can also be a beautiful image on the surface of a lake.

We tend to speak about Narcissus as being fascinated by his own image. But did he really know that this image was his own image and not just an image forming part of the surface of this particular lake? We don't know. We can imagine that he did not know that it was his own image and that he discovered the beauty of this image just as we discover the beauty of a sunset or a

flower. Maybe Narcissus did not want to interrupt his contemplation because he thought that when he came to this lake again the image would disappear – as a sunset or a flower disappear after a while. Or maybe he noted that the image disappears when he moves away – and protecting this image was more important to him than protecting his own life. We cannot know that. When we say that Narcissus loved himself, we should also add that he loved himself not in a way that one usually has in mind – because self-love is generally understood as egoistical self-preservation. Narcissus loved himself not as we love ourselves, but as others admired and loved him – from a distance, as a body in space, as a beautiful form.

It seems that this *metanoia* – the substitution of one's own gaze directed toward the other by the gaze of the other directed toward oneself – is impossible. But Narcissus' discovery of his image in the lake was the discovery of the mediation between my own gaze and the gaze of others. If somebody were to see the image of Narcissus in the lake, that somebody had to see the same image as Narcissus saw. The same can be said about the reflection of a face in the mirror. The same can be said about a photograph, and so on.

The possibility of pictorial representation of the human form creates a zone of mediation between my gaze and the gaze of the other. It is precisely this common zone in which the struggle for my image, my identity, and my status becomes not only possible but, rather, necessary. And it is not merely a fight against the social conventions concerning beauty and public admiration.

Here Narcissus starts a more radical fight – a fight against death as Absolute Master. When the form of my body is transposed from its organic bearer to a different bearer, it begins to circulate beyond the circle of my immediate presence in the eyes of others – and thus also beyond the time of my life. My image belongs to my afterlife because its further existence is independent of my presence. The production of the images is the production of afterlife. Of course, when I die my inner world disappears. But if I have already emptied this world in the name of my public image, then my death loses its edge. And the exposure of one's own body to the gaze of others requires the same degree of *kenosis* as the contemplation of an image. Narcissus practices both types of *kenosis*: he is immersed in the presentation of his own image and in contemplating this image at

the same time. In this sense, Narcissus is already dead – or at least prepared for death – as he looks into the lake: his flesh is as dead as the water of the lake. Of course, Narcissus has mediated his image only partially, for a relatively small circle of contemporaries and for a relatively short time. Today's Narcissus makes selfies and distributes them through Facebook and Instagram. But here the following question arises: to what degree can a photograph really identify a person?

Of course, nowadays one uses photography as the main tool of identification. All important documents, including the passport, contain a photograph of the person that they are supposed to identify. However, can we say that our ID answers the question of personal identification? The answer to this question depends on our understanding of personhood. Usually, when we say that we know and can identify somebody, we mean not only that we can recognize his or her face, but also that we more or less know how this particular person will act, what can be expected from him or her. When someone breaks these expectations, we say that we do not recognize that person any more. That means that the word identity has two interconnected but different

meanings: it means the identity of face and body, but also identity of a certain character, a certain pattern of behavior that is characteristic of a particular person. We know that one should not draw any conclusions about the character of a person based on their appearance. As Hegel argues in *Phenomenology of the Spirit*, an individual cannot reveal the truth of their character through introspection, through the examination of their own soul: such introspection ends in uncertainties and conjectures. But this truth also cannot be drawn from the investigation of this individual's appearance. The human body offers only an image of possibilities that this body can eventually realize.[7] The truth of a person manifests itself only in action that demonstrates which possibilities were realized – and which were not realized. In other words, Hegel believes that individuals can and should be identified not only by an image of their face and body but also by an image of their actions. The medium of this public image of the individual in action is historical documentation. But here the following question emerges: what are we ready to consider as an action? For Hegel, an action means, of course, a political action – war, revolution, introduction

of a new law. Through their history, individuals objectify themselves, make their dark inner space visible, by realizing the possibilities that, as Hegel argues, remain hidden as long as the individual remains passive. However, even if an individual is in control of his or her actions, the question remains: who is in control of the presentation of these actions? According to Hegel, presentation is controlled by the spectator, the historian, the philosopher. It is they who create an image of an action – and place this image in an historical context.

But to achieve public visibility, an individual does not necessarily need to take action. Let us imagine a photograph of Narcissus looking into the lake. Such a photograph would document a seemingly passive state of prolonged, immersive contemplation. However, as it was shown before, in the case of Narcissus we have to deal strictly with the simultaneous act of self-contemplation and the offering of his own image to the gaze of the other. In other words, the state of passivity can also be interpreted as an action – as an act of self-exposure. And such an act of self-exposure puts the individual in control of its image. Here, the individual does not need a historian or a

philosopher, who, at some point in the future, will form and interpret his or her image. On the contrary, precisely in the state of alleged passivity, the individual can dictate his or her image to the spectator here and now – as well as to a future spectator.

3

Siegfried Kracauer discusses the use of photography as a tool of identification in a relatively short article from 1927 entitled "Photography," and comes to the conclusion that photography does not open, but, rather, blocks the way to the inner, spiritual identity of a model. As an example, Kracauer takes a photograph of his grandmother – that is, a private photograph, a photograph of sentimental value – and states that this photograph does not bring back memories of his grandmother but, rather, blocks them. His grandmother as a person, as an individual, as a spiritual being is not disclosed by a photograph, but instead only her outward appearance becomes visible, which reflects the fashions of

her time that are manifested through her clothes and makeup and thus seem impersonal and de-individualized. Kracauer writes:

> Nothing of these [things] contains us, and the photograph gathers fragments around a nothing. When the grandmother stood in front of the lens, she was present for one second in the spatial continuum that presented itself to the lens. But it was this aspect and not the grandmother that was eternalized ... What appears in the photograph is not the person but the sum of what can be subtracted from him or her. The photograph annihilates the person by portraying him or her, and were person and portrayal to converge, the person would cease to exist.[8]

The inner identity of the model cannot be captured through its external features. For Kracauer, every photograph is merely a general inventory of diverse fragments or details that lack an inner unity. Such a unity can only emerge on the level of meaning, sense, signification, and yet this sense and meaning cannot, by definition, be photographed. As a consequence, photography for Kracauer is a mere collection of refuse, a phantom

and a sign of death: instead of vanquishing death, photography kills, for it captures only the body, the corpse, and negates the soul.

Here it is obvious that Kracauer is infected by the Hegelian notion according to which subjectivity, the inner self, reveals itself in action. For Krakauer, it is the specific mode of living and communicating with her relatives and friends that reveals the true spirit of his grandmother. Krakauer keeps the loving memories of his communications with his grandmother. But these memories – being biographic, historic – cannot be found in the photographic image. The photograph that immobilizes the body of the grandmother seems, rather, to build a wall that totally conceals her true self.

Now, it is interesting to observe that Kracauer's strategy is repeated, in all its essential aspects, in a book that belongs to those texts that play a key role in contemporary discussions on documentary photography – namely Roland Barthes's *Camera Lucida* from 1980. Barthes takes photographs of his deceased mother as an example and tries to recognize her in these photographs – but he also does not succeed. The inner being, the true identity of his mother, once again escapes

photographic representation. Instead of his mother, Barthes sees in these photographs – just as Kracauer had – merely impersonal fashions of former times. Only one photograph allows Barthes to say he recognizes his mother, but this photograph shows her as a child – that is, at a time of which Barthes himself has no memories.[9] Only the child is essential – an old Romantic idea that will probably never die.

However, the clothes and makeup that Kracauer's grandmother had used for her appearance in the photograph were obviously chosen by her with the goal of looking good and dignified. Krakauer's grandmother was not merely passive, but actively presented her own image to the gaze of the photographer and, thus, more generally to the gaze of others. Through this action of self-presentation, she revealed her inner world – that is why, as Krakauer writes, there has remained nothing of her beyond what could be seen in the photograph. She manifested her inner world precisely through the choice of makeup and clothes. Krakauer could not remember his grandmother through the photograph because he could not see her in their loving communications. He failed to see her body, her face, her way of presenting

herself. In his memories, only actions and inter-actions remained. To present oneself as an image means to produce oneself as an artwork. But the act and the effort of self-exposure reveal themselves only through disactivation and dis-communication. We have to take a person out of the network of interactions to see what kind of form this person gave to themself.

The same can be said about Barthes and his relationship to his mother. Barthes regrets that the photograph of his mother reflects only the fashions of her time. Indeed, the choice of clothes and accessories is mostly subject to fashion. This is especially true for the well-educated social strata. As Hegel writes in his *Philosophy of Right*, "[b]y educated people, we may understand in the first place those who do everything as others do it and who do not flaunt their particular characteristics, whereas it is precisely these characteristics which the uneducated display, since their behavior is not guided by the universal aspects of its object."[10] Of course, we know that educated people also tend to present themselves as "uneducated" if they want to break with dominant customs, conventions, and fashions. That is precisely why, in the educated classes, one could from time to

time see a return to the "natural man," art of the "primitives," or peasant life. Thus, to follow or not follow fashion is always a subjective decision.

When Krakauer writes that, on the photographs of his grandmother, he could only recognize the fashion of her time and not her subjectivity, he overlooks the fact that our subjectivity is nothing other than our ability to follow the fashion that defines our "here and now" or to break with it. We follow – or do not follow – fashion not blindly and instinctively but, rather, in a conscious and informed way. We want to be contemporary and we want to belong to a certain cultural milieu – and our strategy to follow a certain fashion reflects this desire. Our relationship to photography was well captured by Friedrich Jünger: "The photographic process could be invented only after man had become psychologically ready to be photographed. The new invention, in other words, signifies a change of mind. It was in the degree that the human model adapted itself to portrayal by photography that the new techniques developed."[11]

4

Now, there are communities that reject the historical change in fashions because they understand themselves as transhistorical. Such are the religious communities: Catholic and Buddhist monks, ultraorthodox Jews, Amish, etc. There are also some professions that require the wearing of a uniform – notably, the military. Self-presentation in a uniform is also a conscious decision concerning the self-positioning of an individual in the public space. A uniform demonstrates that an individual is committed to transtemporal values. Such an individual positions him- or herself as representing the universal inside a specific, historical "here and now." That is the reason why avant-garde design in the early twentieth century

looked for something like a universal uniform that could be a manifestation of the essential transtemporal dimension of human existence. The artistic avant-garde tried to achieve this universal uniform by erasing everything that was too historical, too specific, too "original."

As long as God was alive, the design of the soul was considered as a guarantee of the transtemporal, eternal dimension of a human individual. God was thought to be the spectator of the soul. To him, the ethically correct, righteous soul was supposed to look beautiful – that is, simple, transparent, well constructed, proportional, and not disfigured by any dark vices or marked by any worldly passions. It is often overlooked that, in the Christian tradition, ethics has always been subordinated to aesthetics – that is, to the design of the soul. Ethical rules, like the rules of spiritual asceticism – of spiritual exercises, spiritual training – served above all the objective of designing the soul in such a way that it would be acceptable in God's eyes, so that He would allow it into paradise. The design of one's own soul under God's gaze is a persistent theme of theological treatises, and its rules were visualized with the help of medieval depictions of souls waiting

for the Last Judgment. The simple, ascetic, minimalistic design of the soul that was destined for God's eyes was clearly distinct from the worldly aesthetics of the soul that sought richness of materials, complex ornamentation, and spectacular wealth – and that was, therefore, situated in hell. The revolution in design that took place at the start of the twentieth century can best be characterized as the application of rules for the design of the soul to the design of human bodies and other worldly objects.

Previously, the body was considered as a prison of the soul; now the soul became the clothing of the body – the mode of its social, political, and aesthetic appearance. Theosophy, which emerged at the end of the nineteenth and beginning of the twentieth century, played a decisive role in the interpretation of clothing as manifestation of the soul. Theosophy understood soul as aura – and, thus, changed the topology defining the relationship between the soul and the body:

All students know that what is called the aura of man is the outer part of the cloud-like substance of his higher bodies, interpenetrating each other, and extending beyond the confines of his physical

body, the smallest of all. They know also that two of the bodies, the mental and desire bodies, are those chiefly concerned with the appearance of what are called thought-forms.[12]

In its secularized version the aura became the shape of the clothes in which human beings appear, the everyday things with which they surround themselves, the spaces they inhabit. All of them began to be seen as manifestations of the "mental and desire body" of a particular person. Thus, design became the construction of the aura – the medium of the soul, the revelation of the subject previously considered as hidden inside the human body. Accordingly, design took on an ethical dimension it did not previously have. In design, ethics became aesthetics; it became form. Where religion once was, design has emerged. The modern subject got a new obligation: the obligation of self-design, an aesthetic self-presentation as ethical subject. The morally motivated polemic against the conventional, commercial design, launched repeatedly over the course of the twentieth century and formulated in ethical and political terms, can only be understood on the basis of this new understanding

of design as construction of aura. Adolf Loos's famous essay "Ornament and Crime" (1908) is an early example of this turn.

From the outset, Loos postulated in his essay a unity between the aesthetic and the ethical. Loos condemned every decoration, every ornament, as a sign of depravity, of vice. The modern human is expected to present him- or herself to the gaze of others as an honest, plain, unornamented, "undesigned" object. According to Loos, the function of design is not to decorate or ornament things so that their true nature remains hidden. Rather, the function of modern design should be to prevent people from wanting to decorate things at all. Thus Loos describes his attempts to convince a shoemaker from whom he had ordered shoes not to ornament them.[13] For Loos, it was enough that the shoemaker used the best materials with care and dedication. The quality of the materials and the honesty and precision of the work, and not their external appearance, determine the quality of the shoes. The criminal thing about ornamenting shoes is that decoration does not reveal the shoemaker's honesty, that is, the ethical dimension of the shoes. The ethically dissatisfactory aspects of the product are concealed by ornament

and the ethically impeccable are made unrecognizable by it. For Loos, true design is the struggle against decoration – against the criminal will to conceal the ethical essence of things behind their aesthetic surface. Of course, true design – or, rather, anti-design – also creates an aesthetic surface, but this surface should be free from any ornament and, thus, from any fashion.

The messianic, apocalyptic features of the struggle against ornamentation that Loos was engaged in are unmistakable. For example, he wrote:

Do not weep. Do you not see the greatness of our age resides in our very inability to create new ornament? We have gone beyond ornament, we have achieved plain, undecorated simplicity. Behold, the time is at hand, fulfillment awaits us. Soon the streets of the cities will shine like white walls! Like Zion, the Holy City, Heaven's capital. Then fulfillment will be ours.[14]

The struggle against the ornament is the final struggle before the arrival of God's Kingdom on Earth. Loos wanted to bring heaven down to earth; he wanted to see things as they truly are. In fact, he wanted to appropriate the divine gaze.

But not only that, he wanted to make everyone else capable of seeing things as they are revealed in God's gaze. Modern design wants the apocalypse now, the apocalypse that unveils things, strips them of their ornament, and causes them to be seen as they truly are. Now the eternity becomes the only here and now of human existence. The body takes on the form of the soul. All things become heavenly. Heaven becomes earthly, material. Modernism becomes absolute.

Whereas Loos still formulated his argument in rather bourgeois terms and wanted to reveal the value of certain materials, craftsmanship, and individual honesty, the will to absolute design reached its climax in Russian Constructivism. Here, God was substituted by the machine. The October Revolution was understood as the end of history moved by the class struggle. The leisure class – with its fascination for permanently changing fashions and styles – had to disappear. After the history of the class struggle, life becomes equal to work. The experience of the 1917 October Revolution was crucial for the Russian Constructivists. They understood the revolution to be a radical act of purifying society of every form of ornament: the finest example

of modern design that eliminates all traditional social customs, rituals, conventions, and forms of representation in order for the essence of political organization to emerge. For the Russian Constructivists, the path to virtuous, genuinely proletarian objects also passed through the elimination of everything that was merely artistic. The Russian Constructivists called for the objects of everyday communist life to show themselves as what they truly are: as functional things whose form served only to make their ethics visible.

The project of Russian Constructivism was a total project: it wanted to design life as a whole. Only for that reason – and only at that price – was Russian Constructivism prepared to exchange autonomous art for utilitarian art: just as the traditional artist designed the whole of the artwork, so the Constructivist artist wanted to design the whole of society. This totalistic attitude is clearly reflected in the manifestos of Russian Constructivism. For example, in his programmatic text entitled "Constructivism," Alexei Gan wrote:

> Not to reflect, not to represent and not to interpret reality, but to really build and express the

systematic tasks of the new class, the proletariat . . . Especially now, when the proletarian revolution has been victorious, and its destructive, creative movement is progressing along the iron rails into culture, which is organized according to a grand plan of social production, everyone – the master of color and line, the builder of space–volume forms and the organizer of mass productions – must all become constructors in the general work of the arming and moving of the many-millioned human masses.[15]

The modern designer, whether bourgeois or proletarian, calls for metanoia, which would enable people to see the true form of things here and now – the true form that, according to religious tradition, can be revealed only after death. This funeral aspect of modern design was recognized by Loos even before he wrote "Ornament and Crime." In his text "The Poor Little Rich Man," Loos tells of the imagined fate of a rich Viennese man who decided to have his entire house designed by an artist. This man totally subjected his everyday life to the dictates of the designer (Loos speaks, admittedly, of the architect), for as soon as his thoroughly designed

house is finished, the man can no longer change anything in it without the designer's permission. Everything that this man would later buy and do must fit into the overall design of the house. In a world of total design, the man himself has become a designed thing, a kind of museum object, a mummy, a publicly exhibited corpse. Loos concludes his description of the fate of the poor rich man as follows: "He was shut out of future life and its strivings, its developments, and its desires. He felt: Now is the time to learn to walk about with one's own corpse. Indeed! He is finished! He is complete!"[16] In the white city, in the heavenly Zion, as Loos imagines it, design is truly total. Nothing can be changed there: nothing colorful, no ornament can be smuggled in. In the white city of the future, everyone is the author of his or her own corpse – everyone becomes an artist-designer who has ethical, political, and aesthetic responsibility for his or her image. But does the modern individual experience the transtemporal design as liberation from the subjection to the historical fashions, or as imprisonment by the anonymous post-historical eternity? Does the individual still seek the unique, individual experience of

the historical here and now – the lost aura of historical time – or is he ready to reject this aura in exchange for a universal, transhistorical uniform?

5

According to Ernst Jünger the notion of the unique personal experience merely served as the basis for the nineteenth-century individualism that became a thing of the past. In his treatise "The Worker," Jünger argues that traditional bourgeois ideology holds individual life to be absolutely precious precisely because of its supposed singularity. However, the modern subject is the nonindividualized subject of modern technology, that is, the worker. In the context of technological civilization, the individual becomes a bearer of experiences that are impersonal, nonindividual, serial, and standardized. As worker, the subject becomes *Gestalt* – a pure universal form. Although Jünger certainly does not mean that we can no

longer have unique experiences, he argues that such experiences have become devalued because of their nonreplicable and irreplaceable character. The modern individual appreciates only that which has been standardized and serialized.

> So the man who drives a particular car never seriously imagines that he is in a possession of something tailored to his individuality. He would, on the contrary and rightly so, be suspicious of a car existing only as a one-off production. What he tacitly assumes to be quality is rather the type, the make, the properly constructed model.[17]

Such reproducible objects as cars can always be exchanged; in this sense they have a certain indestructibility, a certain immortality. If an individual wrecks his Mercedes, he always has a chance to purchase another copy of the same model. Modern and contemporary technologies do not produce unique, unrepeatable things, but they have something else to offer: the promise of transtemporality, even immortality, a promise that is guaranteed by replicability and reproducibility. The individual follows the same vision of immortality when it serializes its own inner life.

That makes the individual exchangeable and replicable. If all our experiences are reproducible, impersonal, and serial – if our aura becomes a uniform – then there is no longer any convincing reason to value a specific individual over others. In order to survive in technological civilization, the individual human being must mimic the machine. The machine actually exists between life and death; although it is dead, it moves and acts as if it were alive. As a result, the machine often signifies immortality. Although the prospect of becoming a machine might seem dystopic or nightmarish for most, for Jünger this becoming-of-machine was the last and only chance to overcome individual death. And it is not any more the soul that becomes immortal, but a form of life, an aura – visible to others and not concealing any personal, unique experiences and feelings.

In this respect, Jünger's relationship to institutions of cultural memory such as the museum and the library is especially characteristic, since, in the context of modernity, these institutions are the traditional carriers of corporeal immortality. But Jünger despises museums and libraries because of their role in preserving one-of-a-kind

objects that exist beyond the limits of serial repro-
duction and, thus, have "a status of curiosity."[18]
Instead of maintaining the museum as a space of
private aesthetic experiences, Jünger wants the
public to reorient its gaze and to contemplate the
entire technological world as an artwork. Like
the Russian Constructivists of the 1920s, Jünger
understands the new purpose of art as identical
with that of technology, namely to aesthetically
transform the whole world, the whole planet,
according to a single technical, aesthetic, and
political plan.

Jünger describes the dominance of anony-
mous, serialized modernity and the emergence
of an aesthetically conformist, trivialized man-
kind as effects of the historical process – the
process that he describes as having a fateful,
impersonal, "objective" character. However,
as was shown earlier in the examples of Loos
and Russian Constructivism, we have to deal
here with the conscious decisions and actions
of self-presentation whose goal was to tran-
scend all local and temporary historical fashions
– self-presentation of the human form as anony-
mous, repetitive, and transtemporal. Here, as in
the case of photography, the aesthetic decision

by an individual precedes the technical means that made it visible.

Technology must be *seen* in a certain way to emerge; it must manifest a new self-design, a new aura, a new promise of immortality. Jünger's goal was to bring the reader to see technology in a new light. Here the whole world had to be seen as readymade. Marcel Duchamp already demonstrated this possibility when he installed everyday objects produced by modern civilization into the museum context. However, such a change in perspective itself constitutes a unique aesthetic experience, a singular aesthetic operation that is neither replicable nor serializable. Jünger claims in his treatise the impossibility of unique personal experience, but *The Worker* presents itself at the same time as a description of such a unique aesthetic experience. It is the performative paradox that lies at the core of Jünger's text – as also in many other texts that deplore the aesthetic monotony of modernity and our own time. In the technological world that Jünger conjures up in *The Worker* the text itself would be incomprehensible because such a world would have no place and no need for its own aesthetization. The possibility of such an aesthetization

emerges through a comparison of technological modernity with older cultural formations that also demonstrated a high degree of seriality and regularity. Thus, Jünger is fascinated not only by the world of machines and military uniforms, but also by the worlds of medieval Catholicism and Greek architecture because all three of them are characterized by regularity and seriality.

The conscious character of the decision to submit one's own body to the requirements of regularity and seriality becomes obvious in sport. Sport is a manifestation of desire of contemporary human beings to achieve the form of the classic Greek human body. Modern sport is the Renaissance for the masses. The Olympic games took the position that was earlier occupied by the French salon painting. They are an attempt to realize the classic ideal of humanity on a mass scale. Today, it is not art but sport that connects our culture to its antique roots. This connection was ingeniously thematized by Leni Riefenstahl in her film *Olympia* in the first sequences of which the ancient Greek sculptures morph into the bodies of the Modern athletes. Sport marks the rebirth not only of the classical body but also of the classical virtues – the sane spirit in the sane

body, harmonious development of personality, balance between the physical and the spiritual, dedication to one's goal, fairness in competition.

Athletic bodies are idealized and, as it were, formalized. Looking at them, the spectator cannot imagine these bodies becoming ill or infirm, transforming themselves into the vehicles of obscure desires, decaying, or dying. Rather, formalized athletic bodies serve as allegories of corporeal immortality. These bodies seem immortal because they are, like machines, indefinitely exchangeable, substitutable. They are not natural bodies but, rather, artificial products of training.

If we are to believe memoirs or biographies of famous athletes, we can see that they were trained primarily to switch off their subjectivities – memories, plans, emotions, thinking, and self-reflection. To become successful, sportspeople have to learn to empty their inner world and desires of their flesh and to let their bodies act beyond any conscious control. Masters of the Eastern martial arts, in particular, preach that switching off consciousness is the crucial precondition of victory and success. Also, in business and everyday life, "gut feeling" is praised as being a better guide than intellect.

Training can also serve in the preparation for war or revenge. The trainee leaves society for a while but then re-enters it in a spectacular manner. Not accidentally, in many recent movies, like, for example, Tarantino's *Kill Bill*, the heroine spends a long time training in the martial arts in a semi-monastic condition so as to be able to stage her violent return. Preparations for a revolution are also necessarily secretive. Revolutionaries should subject their lives to training and preparation for the revolutionary event. Of course, it can happen that the revolutionary moment never emerges during their lifetime. Waiting for the revolutionary moment – and training for this moment – reminds one of the millenarian sects that are waiting for the imminent second coming of Christ. In the religious tradition, the period of training is supposed to last until the end of human life – until the moment when the believer appears in front of the divine eyes. And it is obvious that the believer will not shorten the period of waiting but will, rather, delay a direct encounter with the divine spectator. The narcissistic strategy of delay is also characteristic of modern artistic and literary practice called "work in progress."

In all these cases, waiting and training – which is an active form of waiting – are the narcissistic practices par excellence whose goal is to isolate the individual from their social milieu and at the same time give them a form that is similar to all the others who are waiting and training. One can argue that training is a contemporary form of self-contemplation. The training is a lonely activity that takes place away from the public eye. And it is, actually, only one activity that is recognized and accepted by our society as bestowing on an individual the right to be lonely. Or, in other words, as the only socially recognized form of pure narcissism. Everything else is increasingly becoming collaborative and socialized. But training cannot be collaborative. Even when one goes to a gym, one remains alone. One is collaborating only with the machines that help one in the process of self-machinization. One works on oneself – one's own body, own mind, own reflexes and reactions, own mimic, own look, etc. Training allows one to take leave from a society with a promise to re-enter it in a better, more successful form. But how plausible is such a promise?

Of course, training cannot offer any guarantee of success. It is the period of training and

waiting for recognition and success that offers the most intense narcissistic self-contemplation and self-enjoyment – the time that abruptly ends when the trainee re-enters society. Indeed, when the event of re-entering happens, one is supposed not to think or feel anything at all – only to act according to one's training. Training turns a human being into an automaton that has no inner dark space of subjectivity. Aesthetization is intimately related to automatization. Whatever kind of training the contemporary Narcissus practices, his goal is not only to empty his inner world but also to overcome the specificity of his natural body. For the mythological Narcissus too, his DNA or fingerprints that would be able to identify him as this particular person were irrelevant. In his own image, he saw only a manifestation of the universal ideal of beauty. The modern Narcissus is not so much interested in beauty, but he wants to be recognized and admired by many – as one of them. Here again, the gaze of others is assumed to be similar to the divine gaze. Indeed, we know that all angels look alike.

6

However, what about modern and contemporary art? The artist also practices self-aesthetization, but contemporary art does not presuppose any training. That is, actually, the main difference between traditional and contemporary art: traditional, academic art required training, but the waves of the twentieth-century artistic avant-garde made this requirement obsolete. Modern art was understood by its protagonists as a search for the true, natural, untrained, unconventional Self. Artistic modernity was produced by educated people who presented themselves as uneducated – as not knowing what society expects from them. The modern artists practiced destruction of everything conventional and traditional in the

artwork and in the artist. This process of destruction is well illustrated by the Cubist dissection and recombination of the fragments of the visible world. One used to say that we are confronted here with original, unique, "subjective images." But in what sense? It is hard to believe that the Cubist painters "naturally" saw the world as they represented it on their paintings. Rather, their art suggests that the usual image of the visible world is a human, all too human, convention that can be easily broken. Modern artists do not see things in a different way – they take the freedom to present things to the gaze of others in a different way. That is true also for the so-called "expressionist" painters: when Franz Marc paints horses blue, that hardly means that he sees them blue – that means only that he feels himself empowered to break with his own vision as well as with the common vision of the horses.

For a very long time, art was seen as mimetic – as representation of what people see. These visions could be ecstatic, religious visions of paradise and hell, or secular, profane representations of natural landscapes and particular objects, including human figures. Modern artists began to make new things that could not be seen before

they were produced by an artist. In this respect, modern and contemporary art acted in parallel to modern technology. But art produced new things that were not to be used, but only looked at.

Now, looking at something means always looking at it in a certain context – inside a certain frame or, one might say, inside a certain aura. One can even assert that it is the frame that makes an image. This insight, which was fundamental for contemporary art, was manifested already through the famous *Black Square* by Kazimir Malevich. Here the image is reduced to its most universal scheme: a framed fragment of surface. In such a reduced and universalized form, it can be appropriated and repeated by everybody and frame everything. One can frame an everyday object and turn it into a "readymade." One can frame part of the space and turn it into an artistic installation. One can frame part of a political space, social movement, project, or discourse and present it as an artwork. The operation of framing becomes universal and anonymous. Modern art is as uniform in its methods as modern sport. However, if sport works on a human body inside a fixed frame, modern and contemporary art operate with a frame that leaves the body intact.

The strategic positioning by the artist of his or her "natural" body in public space turns this body in an artwork – beyond any training.

The main task of today's artists is to position themselves. Narcissus positioned himself in an almost perfect way by framing the reflection of his body in the lake. The contemporary Narcissus has to artificially create such a frame – using the elements of reality, the artistic tradition, and the technology of his or her time. One can reappropriate one's own empirical identity and put it in a certain cultural frame. One can deviate from it. One can combine it with other identities and thus create mixed, complicated, and fluid identities. Today, cultural production is basically identity production. And even if produced identities are often highly individualized, the mode of their production is universal and repetitive. In this sense, also, modern and contemporary art belong to the technological age.

In our time, people are speaking a lot about the politicization of art. It is really a very important issue. But its importance is a result of another phenomenon – the aesthetization of politics. We are living in a society of almost infinite proliferation of political ideologies, programs, plans,

discourses, and movements. They all seem attractive – and they all proclaim the common good as their superior goal. How can an individual prefer one political attitude to another if all of them seem to be equally persuasive? The only way is to switch attention from the program to its author and protagonist. Here again, it is the aestheticized body of the politician that attracts us and seduces us to support him or her. Political space becomes organized with this body at its center – it becomes a frame, an aura of the politician.

The framing of a certain environment and self-positioning inside it makes this environment auratic. When Walter Benjamin speaks about the aura of an artwork, he means precisely the original natural and cultural environment of this artwork. But such an environment may not only be lost, but also newly constructed. Thus, one can say that the lake and the whole natural setting around it framed Narcissus' body and thus built its aura. However, can one say that the figure of Narcissus was somehow natural, ordinary – typical for a certain place and time? Obviously, not. Narcissus breaks with the usual way of life of his time. He turned himself into a statue and,

thus, transformed his surrounding into an exhibition space. But that means that the artist, this modern Narcissus, also can turn every natural or urban context into an exhibition space. In other words, the artists can construct auras for themselves and their artworks. The artwork does not manifest any personal "vision" of the artist. It functions from the beginning as an artificially produced object of contemplation by others – together with the space in which it was originated and/or the space in which it is exhibited.

Artists practice self-framing, self-design – using their bodies and lives as readymades. This self-aesthetization started already in the time of Romanticism and has since then become ubiquitous. Of course, unlike Narcissus, the artist should not necessarily look beautiful. Art has already gone a long way toward substituting commonly recognized beauty with individual acts of aesthetization. Meanwhile we have learned to recognize every artistic act of aesthetization, including self-aesthetization, as legitimate. Today's Narcissus proves his status of being beautiful by the mere fact of looking into the lake – by the act of self-framing as a beautiful object. In other words, the artist is a democratic Narcissus who

shows everybody how to become an object of self-aesthetization.

Such self-framing is always polemical. It is polemical because we are always already framed in the eyes of others – put in a certain cultural, social, political, and aesthetic context. The narcissistic desire is a desire to get one's own external, social image under control – to become a sovereign master of one's image. This desire leads to a struggle in which art, design, literature, media, politics, and, in general, culture are the platforms. One can argue that this struggle is lost from the start because the others always have a surplus of vision in relationship to our living body – and also in relationship to the context in which this body is exhibited. Others are surrounding my body from all sides – that is my first and foremost experience of society. And this surplus of vision is permanently growing, as is demonstrated by the emergence of the Internet. However, as we have seen, art and culture allow us to construct new frames in which our bodies become situated. These frames consist of artworks, texts, films, buildings, and all the other artifacts that we have created. But also of the laws that we have adopted and political decisions that we have taken. These

artificial frames proliferate and become integrated with nature and culture: other people live in the buildings that we have built, read the texts that we have written, and obey the laws that we have formulated and adopted. In fact, the Internet expands this proliferation. So one can say that others also become framed by the frames that we have created. The surrounding becomes sur-rounded. More recently, people speak so much about the necessity to care for the environment. But for us to care for the environment is possible only if we are, actually, the environment of the environment.

Of course, one can argue that modern and con-temporary art and design are specialized activities – so that everything that was said before concerns only a fraction of contemporary society. But this would be wrong. Like modern industry and con-temporary information technology, modern art and design changed the world in an irreversible way. Every citizen of the contemporary world is challenged to take ethical, aesthetic, and politi-cal responsibility for his or her self-design. In a society in which design has taken over the func-tion of religion, self-design becomes a creed. By designing oneself in a certain way, one declares

one's faith in certain values, attitudes, programs, and ideologies. An individual can present itself – in the best Romantic tradition – as demonic, decadent, having no future. But also in this case, self-design remains an ethical-political statement. One can speak about the design of power but also about the design of resistance or the design of alternative political movements. Here, design is practiced as a production of visible differences – differences that at the same time take on a political semantics. We often hear laments that politics today is concerned mostly with image – and that so-called content loses its relevance in the process. This is thought to be the fundamental malaise of politics today. Accordingly, there are calls to turn away from political design and image-making and return to the content. Such laments ignore the fact that, under the regime of contemporary political design, it is precisely the visual positioning of politicians in the field of the mass media that is able to convey their politics – or even constitutes their politics. Content, by contrast, is completely irrelevant, because it changes constantly. Hence the general public is by no means wrong to judge its politicians according to their images – according to their basic aesthetic

and political creed, and not according to arbitrarily changing programs and contents that they support for a while and then abandon.

Thus, contemporary design evades Kant's famous distinction between disinterested aesthetic contemplation and the use of things guided by interests. For a long time before and after Kant, disinterested contemplation was considered superior to a practical attitude: a higher, if not the highest, manifestation of the human spirit. But already by the middle of the nineteenth century, a re-evaluation of values had taken place: *vita contemplativa* was thoroughly discredited, and *vita activa* was elevated to the true task of humankind. Today, design is accused of seducing people into weakening their activity, vitality, and energy – of making them passive consumers who lack will, who are manipulated by omnipresent advertising and thus become victims of capital. The apparent cure for being lulled into sleep by "the society of the spectacle"[19] is a shock-like encounter with the "real" that is supposed to rescue people from their contemplative passivity and move them to action, which is the only thing that promises an experience of truth as intensity of life. The debate now is only over the

question whether such an encounter with the real is still possible or whether the real has definitively disappeared behind its designed surface.

However, if we can speak of disinterested contemplation of images we cannot speak of disinterested image production. We are interested in self-manifestation, self-design, and self-positioning in the aesthetic field, since, as subjects of self-presentation, we clearly have a vital interest in the image we offer to the outside world. Once people had an interest in how their souls appeared to God; today they have an interest in how their image and their aura appear to other people. This interest certainly points to the real. The real, however, emerges here not as a shock-like interruption in the designed surface, but as technique and practice of self-design – not in the field of contemplation but, rather, as a mode of production. In his day, Joseph Beuys said that everyone had the right to see him- or herself as an artist. What was then understood as a right has now become an obligation. In the meantime we have been condemned to being the designers of our selves.

7

Public visibility and aesthetic responsibility are not only rights and duties; they are also a heavy burden that one tries to avoid. There is a narcissistic desire for visibility – but there is also a no less narcissistic desire for invisibility, secrecy, privacy. Both desires are equally narcissistic because both of them have the same goal of taking control of our own public image. We do not always want to be visible, exposed, and observed, because being visible means also being vulnerable. However, in our contemporary culture the desire for invisibility is considered as criminal. And, indeed, why should somebody want to be invisible? The most obvious explanation: to commit a crime and remain unpunished. To prevent such an eventuality,

our contemporary civilization has developed a complicated system of surveillance that makes invisibility virtually impossible. This system of total control is a direct consequence of the death of God – the loss of the universal spectator of all souls. If human souls are not surveilled and controlled by God, then human bodies should be observed and controlled by the police.

In his novel *The Man Who Was Thursday* (originally published 1908) G. K. Chesterton describes a special department of the English police force as a divine institution presided over by God himself, who is surrounded by mythical figures – embodiments of the six days of the creation. According to the novel, these six persons represent a kind of the ontological police that created our world by installing the visible cosmic order – beginning with the separation between light and darkness. And police officers still act as protectors of this order against the hidden, clandestine forces of nihilism and anarchy. However, to be the ideal, privileged, truly informed spectators, the police have to act undercover. As Chesterton's mythical policemen are not invisible, they have to hide themselves beneath the masks of anarchists-terrorists. In other words, to be efficient, they

have to become even more invisible than terrorists – potentially as invisible as God himself. But it is, of course, impossible because police officers are also public figures. Indeed, they wear a uniform – and in this sense they embody the transtemporal form of narcissism.

In one of his poems, Russian poet Dmitri Prigov cleverly described the Christ-like figure of a policeman (Militiaman) as an earthly incarnation of the invisible divine gaze:

> When the Militiaman stands here at his post . . .
> The Militiaman looks to the West, to the East –
> And the empty space beyond lies open
> And the center where stands the Militiaman –
> He can be seen from every side
> Look from anywhere, and there is the Militiaman
> Look from the East and there is the Militiaman
> And from the South, there is the Militiaman
> And from the sea, there is the Militiaman
> And from the heavens, there is the Militiaman
> And from the bowels of the earth . . .
> But then, he's not hiding.[20]

The policeman is godlike but he is not a god. For him, to see means to be seen. This is the

main condition of contemporary spectatorship. God of the Bible could not be seen. Also Reason can see but the gaze of Reason cannot be seen – Reason as such does not have any particular body. However, human spectators have bodies and thus are – at least potentially – delivered to the gaze of other spectators. That is why police officers also have to hide from time to time. To become ideal, invisible, godlike spectators, humans have to hide, to conceal themselves, to escape the gaze of others who try to visualize them – to discover their bodies and, thus, to make them vulnerable.

Conflicts around public visibility or invisibility constitute the main plot of our contemporary popular culture, which makes the cat-and-mouse play between police officers and criminals its main content. Indeed, contemporary mass culture, including popular novels, movies, and TV series, is dominated by stories depicting the conflict between the police and crime. The role of the police is to make publicly visible everything that wants to remain in the dark. By means of surveillance and investigation, the police reveal personal or corporate secrets and give those who are involved in them and want to keep their incognito a visible public form. But insofar as

the police work in secrecy, they act as a criminal organization – and become an object of investigation. There is no invisible gaze anymore. Every gaze becomes situated, framed – and investigated by the gaze of the other.

This characterizes all the aspects of everyday life, but it is especially obvious in the context of the Internet. As Narcissus looked into the lake, he did not affect it and his gaze did not leave any traces on it. The traditional notion of spectatorship is based on the subject–object relationship with the following basic characteristic: the gaze of the subject does not leave any traces on the object. It is precisely this absence of any material traces of the gaze that suggests the metaphysical, spiritual, immaterial, transcendent status of subjectivity – of the Self. The subject is believed to be not of this world because its gaze does not leave a trace in this world; looking at the object is not the same as touching it. That is the basic difference between seeing and touching – between subject–object and object–object relationships.

In his *Visible and Invisible*, Maurice Merleau-Ponty famously argued that seeing is a kind of touching – not because the gaze touches the object, but because the rays of light that are

refracted by the object touch the eyes of the spectator.[21] Merleau-Ponty's goal was to contest the ideal, transcendent status of the subject. If seeing is a mode of touching, then the subject is in the world, not outside it. And that is precisely what happens on the Internet. There, subjects cannot take an external, transcendent position because their gaze leaves a digital trace.

The subject calls up an image or a text on the Internet by clicking and operates it by moving it on the screen. To be able to see an image, I have to click its name and then maybe look at some details, and compare this image with other images, etc. All these operations leave traces. Indeed, if I inspect an image on the Internet, the movement of my gaze can be retraced. One can find out how long I looked at an image, what the details were in which I was interested, etc. Additionally, my email address can be established, and my physical position in real space can be localized. My use of Internet images or texts can be also correlated with my purchases, ticket and hotel reservations, and all other forms of my ordinary life activities. Thus, the subject cannot take an external, transcendent position toward the Internet because seeing it means clicking, touching it.

We hear a lot of complaints about how big corporations and various state agencies track our personal use of the Internet to create an image of our behavior, tastes, environment, and personal lives. The Internet is often seen as a place of the de-materialization of the things of this world, but it is first of all the place of the materialization of the Internet's user. Every visualization of a digital image is at the same time a manifestation of the user's own image – an act of self-visualization. Looking at a digital image, I produce an image of myself – and offer this image to an invisible spectator hidden behind the surface of my personal computer's screen.

That is the basic difference between the lake and the Internet. This difference can be neatly illustrated by Oscar Wilde's short prose poem about Narcissus, under the title "The Disciple":

When Narcissus died the pool of his pleasure changed from a cup of sweet waters into a cup of salt tears, and the Oreads came weeping through the woodland that they might sing to the pool and give it comfort.

And when they saw that the pool had changed from a cup of sweet waters into a cup of salt tears,

they loosened the green tresses of their hair and cried to the pool and said, "We do not wonder that you should mourn in this manner for Narcissus, so beautiful was he."

"But was Narcissus beautiful?" said the pool.

"Who should know that better than you?" answered the Oreads. "Us did he ever pass by, but you he sought for, and would lie on your banks and look down at you, and in the mirror of your waters he would mirror his own beauty."

And the pool answered, "But I loved Narcissus because, as he lay on my banks and looked down at me, in the mirror of his eyes I saw ever my own beauty mirrored."[22]

Oscar Wilde's pool was obviously a precursor of Merleau-Ponty because it saw the eyes of the spectator only as a passive mirror for its own reflection. But the Internet sees spectators as active users – and creates its own frames for their activities. When in times of Greek antiquity one looked at a statue of Venus, one knew that Venus also looked at the spectator. That is why one was ready to kneel in front of this statue and offer a tribute to it. The same can be said about the Christian icon. During the time of modernity, an image – every

image – became a mere thing, a mere object. One looked at an image – but the image did not look back because it was understood as "merely material." However, our experience of contemporaneity is defined not so much by the presence of the things to us as spectators but, rather, by our presence to the gaze of the hidden, invisible spectators. We do not know how the algorithms that watch and analyze our behavior are functioning, but we know for sure that behind these algorithms other humans are hidden who see us but remain invisible to us. Of course, we also do not know if these hidden humans are the most perfect invisible police or the most vicious criminal organization – or a combination of both. In fact, one assumes that there are many such invisible organizations involved in a cyberwar against each other – a war of identification, of giving a body to the spirits hidden behind the Internet algorithms.

The reaction of Internet users to their own visibility can take different forms. As so-called content providers, users can experience narcissistic enjoyment through placement of their images, texts, videos, etc. But also, for a passive user, the Internet functions as an extremely narcissistic

medium – as a mirror of our individual interests and desires. Indeed, the Internet user finds on the Internet only what he or she wants to find there. In the context of the Internet, we communicate only with people who share our interests and attitudes – be it political or aesthetic attitudes. The nonselective character of the Internet is an illusion. The factual functioning of the Internet is based on the non-explicit rules of selection according to which users select only what they already know or are familiar with. And the Internet not only mirrors, but also remembers the image of our desiring Self – our soul, if one will.

That is why reaction to Internet visibility also takes on a form of narcissistic defense: one tries to protect oneself from the evil eye of the hidden spectator by means of codenames and passwords. The contemporary subject is at best defined as an owner of a certain set of passwords. However, the technical means are not really helpful here because the entanglement of the subject in the Internet web has an ontological character. When in the "real world" everyone is surrounded by others, in the context of the Internet humankind as a whole is caught in the artificially produced net.

That is why many people think that, after the death of their analog bodies, their digital virtual bodies will survive somewhere in a digital cloud – and that these digital bodies can then be called back to earth by any user. Today, the digital cloud is a substitute for the traditional heaven – and Google is a substitute for divine memory. Here, electricity is used as the energy that activates the digital virtual bodies of the living and the dead. The Internet, unlike the museum, is not directly accessible to us as users. We can connect to the Internet only if we switch on our computers and smartphones. In this case they become similar to the tables used during Spiritist séances – both become energized, electrified. It is this energy that allows us to call the spirits of the past that present themselves as "information," as "content" activated and transmitted by electric energy.

Indeed, the word "medium" originally emerged in the context of Spiritism. As early as 1861, Allan Kardec, a French specialist in Spiritism, wrote *The Book on Mediums.* Speaking about *mediums*, he means people who are, as it were, electrified by an energy that is different from their own life energy – and, thus, become able to transmit

messages of the dead during Spiritist séances. Kardec speaks about the responsibility of mediums to become the true, authentic vehicles of the spirits that were invoked by the participants of the seance. However, there is a question as to what degree mediums are able to connect to these spirits. For example, it might happen that the spirit of Napoleon is summoned, but a message from a very different spirit, not that of Napoleon, is instead presented by the medium. If a spirit says to you through a medium "I am Napoleon," then how can you know whether it is a true or a false spirit? Here a lot depends on the character of a particular medium, but it is difficult to find out whether or not this medium is honest and reliable. One calls a spirit but meets the medium. Or, as Marshall McLuhan said later, "The medium is the message."

But even more important is that the honesty of the medium does not guarantee that this medium connects to the called, and not to some other, spirit. Indeed, mediums establish a connection to spirits in a state of self-oblivion in which the mediums are not able to activate their own ability to differentiate between spirits. The same is true for the Internet. It seems that the connection

through the Internet is transparent and, thus, honest and reliable because the construction of a computer or smartphone excludes the possibility that they lie. But, as in the case of Spiritism, these tools of communication cannot guarantee that the user is connected to the same person and the same content to which this user wanted to be connected. According to Kardec, spirits can lie and present themselves as somebody else. Of course, humans who operate the Internet's algorithms can do so too. Digital clouds do not promise any reliable form of afterlife that would offer us the possibility of being connected to the digital bodies of the dead.

8

In this respect, the traditional, analog forms of afterlife are much more efficient. One meets the images and documents of the past also when one does not want to invoke them. One lives in a building built in the past, obeys laws adopted in the past, and travels on roads constructed in the past – even if one does not like them. We constantly meet public corpses of the dead, but we also produce our own public bodies that will function in the future as our public corpses. We document and record images of others, and others are documenting and recording our images. It is an anonymous and collective process. Even as we – moved by the narcissistic desire – produce our own public images, taking selfies, creating

paintings, or writing novels, we use the means of production that are offered to us by the civilization in which we live. This production of public images guarantees to us the material afterlife that is today a substitute for the former promise of spiritual afterlife.

One often speaks about "historical memory" as the contemporary form of afterlife. However, the memories of ourselves disappear soon enough after our death. Conversely, our materialized public images exist for longer. Thus, the phrase, according to which somebody is "kept in the memory of mankind" is, actually, wrong. We know Leonardo da Vinci not because we "remember" him, but because we see his paintings in museums, their reproductions in books, etc. In other words, the image of Leonardo is not something that we remember from the past but something that we meet here and now.

In the context of his discussion of biopolitics, Michel Foucault has written that our civilization is interested in us only to the extent that we are alive. When we die, the state returns our corpses to the obscure sphere of privacy – giving them to our families who are supposed to bury them according to the traditional religious rituals that

already long ago lost their significance and power in "real life."[23] In his book *Symbolic Exchange and Death*, Jean Baudrillard follows Foucault and also speaks about the alleged complete removal of the dead from modern society.[24] But does secular modernity, indeed, ignore the dead? If that were the case, one would not find museums in centers of major cities all around the contemporary world. One would not be able to go to a library. One could not enter a university and be taught history, philosophy, art, and literature. In a museum, library, or university, we are confronted with the public corpses of dead authors. This confrontation is by no means reduced to passive contemplation, reading, and learning. The past offers us models for imitation, appropriation, and revival that we practice time and again – in a conscious or unconscious manner. It is hard to imagine that Foucault himself believed that he would totally disappear after his death – otherwise he would not invest such a great amount of work into the production of his public corpse in the form of his books. The mythological Narcissus got his public corpse as a gift from the gods in the form of a beautiful flower. But the contemporary Narcissus has to work to produce it.

Of course, not all public corpses are treated by the public in the same way. When one speaks about historical memory, one means that some public corpses are kept visible (remembered) but many others are overlooked (forgotten). Now let us use an example to demonstrate how the line functions between the visible and the overlooked. In our contemporary urban spaces, surveillance systems register and record more or less everybody and their movements. However, in general, nobody is interested in these recordings and they mostly remain overlooked. The situation changes when somebody decides to enter the public space by, for example, committing a terrorist act. Suddenly, public media show us a huge gallery of images of this person: how he/she was behaving at the airport, what he/she bought in the supermarket, etc. In other words, the line dividing the visible and the overlooked changes its trajectory: the images that were earlier overlooked become publicly visible.

This example shows that the dominating images are not always images of the dominant class. Visibility does not necessarily mean celebration – often enough it means danger and suspicion. Indeed, if somebody commits a terrorist act,

people begin to ask the question: why did this person do that? One can come to the conclusion that this person became a terrorist because of being crazy or because of economic conditions. But the point is that society becomes interested in this person. People look at this person and they do not understand why he or she did what they did. To answer this question, they begin to reconstruct the person's life, to investigate the materials documenting that life. That is why terrorists so often write a manifesto. They know that their motives will be investigated and, thus, they will be offered a chance of self-design. And it is especially true when one has committed a strange and not quite explicable crime. If somebody goes to a supermarket and steals something, it is a crime but it is not an interesting crime because its motive is clear. What is interesting is when a crime is inexplicable, when its motives are unclear. Then people take a second look, a third look, and so on – they write their commentaries and thus the machinery of cultural production begins to work and is actually what creates the public corpse, the mausoleum. One can say here that "criminal" individuals play with coverage through the media to create their public images.

They appropriate and use for their own goals surveillance through the contemporary police state.

The same can be said about artists. They also break the rules of art production to attract the attention of the media. As long as artists remain inside the usual framework, they run the risk of being overlooked. But the moment an artist starts to do something strange, or commits a kind of symbolic crime, society begins to look for a reason for that. That is why so many of the avant-garde artists also wrote a manifesto. Artworks are the primary art documents. But we also have stories about artists, their own memoirs and memoirs about them, documentations of their exhibitions, their political positions, love stories, and so on. We take all that as one image. We cannot differentiate between artworks and other documents. Every artwork is just one document among many others produced by an artist. The image that the artists finally offer to society is a combination of the images that they have actively produced and the images produced by the media and surveillance systems. For society, all these images are equally valuable, because all of them belong to a public body of a particular person. And that means: my public body is never my own creation.

It is a combination of what I produced and how I have exposed myself – voluntary and involuntary – to the machine of surveillance and recording.

But if self-design is based on the idea of committing a crime, it is crucial here that one has also to be punished for it. Look at the basic narratives of our culture: Christ committed a crime, because he broke the religious law. But he did not want to escape punishment for that. That is why the cross – the symbol of punishment – became the symbol of Christianity. The same of course is true for Socrates, who also was punished by death for his philosophy and did not want to escape punishment. I have chosen these two examples because one marks the origin of European religion and the other marks the origin of European philosophy. In both cases, the plot is the same: one commits a crime and accepts the punishment. I think the clearest description of this plot was done by Søren Kierkegaard in his *Fear and Trembling*.[25] He speaks there about Abraham, but the principle is always the same: you hear a call, someone addresses you and you answer this call. Whatever you do after you have answered this call becomes obscure to others, because they did not hear this call. One cannot place this call

in the normal context of life, it is never quite clear what it was and where it came from. But one begins to react to it. This call is obviously the call of death. Death calls me and I answer this call and begin to operate from the perspective of death. One cannot situate the source of this call in the present. And one also cannot situate it in the past. Death is somewhere in the future. It is the future per se. My public corpse calls me – and I react to this call by trying to make my public corpse visible or, on the contrary, to hide it from the future.

But should I really care about my future public corpse? Is it not better to abandon all interest in the future and live only here and now? Well, maybe it is better – but it is impossible. As was already said, our public body does not belong to us – it belongs to others and we can only partially control it. Our public corpse also belongs to others – we cannot die without leaving a corpse behind. The production of our public bodies and, thus, our public corpses is a cultural process that cannot be stopped by our unwillingness to participate in it. We can only influence to a certain degree the shape, the design, of our public corpse – but we cannot prevent it from being apparent.

The most spectacular installations of public corpses are museums. During the period of modernity, museums were often criticized and even cursed. One wanted to destroy museums to be able to live in one's own time without interference from the past. But is the destruction of museums, archives, libraries, and other institutions of historical memory a good way to access pure, uncompromised contemporaneity? In fact, this project itself is an old project – well documented in the historical archives. When we immerse ourselves in historical archives, the first things we learn about are wars and revolutions, destructions and erasures of the past. Human history is the history of iconoclasm – of destruction of old monuments and cancelations of old authorities. Philosophy, literature, and art merely repeat this pattern. Descartes rejects all traditional knowledge and discovers himself as a thinking ego; Faust rejects all the books of the past and plunges into a life of pleasure.

In his "Futurist Manifesto" (1909), Italian poet Filippo Tommaso Marinetti called for the destruction of museums and historical monuments and celebrated the beauty of cars, trains, and planes. Today, the specific models of cars,

trains, and planes from Marinetti's time are forgotten, but his Manifesto is well preserved in the cultural archives. The artworks that we find in our museums are mostly the revolutionary artworks that proclaimed and demonstrated the rejection of the artistic conventions of the past in the name of pure contemporaneity. The same can be said about our libraries. What the past teaches us is precisely that to reject the past is the best way to enter the cultural archives.

It is often said that artworks are commodities. But the artwork is a commodity that is different from other types of commodities. The basic difference is this one: as a rule, when we consume commodities, we destroy them through the act of consumption. If bread is consumed by us (eaten), then it disappears, ceases to exist. If water is drunk, it also disappears. Clothes, cars, etc. also get worn out and are finally destroyed in the process of their use. Consumption is destruction. Artworks, however, do not get consumed in this way. They are not used and destroyed but merely exhibited or looked at. And they are kept in good condition, restored, protected. So, our behavior toward artworks is different from the normal practice of consumption/destruction.

The consumption of artworks today is simply their contemplation, and such contemplation leaves the artworks undamaged.

This status of the artwork as an object of contemplation is actually relatively new. The classical contemplative attitude was directed toward immortal, eternal objects like the laws of logic (Plato, Aristotle) or God (medieval theology). The changing material world in which everything is temporary, finite, and mortal was understood not as a place of *vita contemplativa* but of *vita activa*. Accordingly, contemplation of artworks was not regarded as ontologically legitimate. This contemplation was made possible by the technology of storage and preservation. Initially, it was the French Revolution that turned things that were earlier used by the Church and the aristocracy into artworks, by exhibiting these objects in the Louvre, only to be looked at. The secularism of the French Revolution abolished contemplation of God as the highest goal of life and substituted it with the contemplation of art. In other words, art, as we know it, was produced by revolutionary violence, and was from its beginnings a modern form of iconoclasm. Indeed, during premodern history, a change of cultural

regimes and conventions, including religious and political systems, led to radical iconoclasm, the physical destruction of objects related to previous cultural forms and beliefs. The French Revolution offered a new way to deal with the valuable things of the past. Instead of being destroyed, they were de-functionalized and presented as art. It is this revolutionary transformation of the Louvre that Kant had in mind when he wrote in his *Critique of the Power of Judgment*:

> If someone asks me whether I find the palace that I see before me beautiful, I may well say that I do not like that sort of thing . . .; in true Rousseauesque style I might even vilify the vanity of the great who waste the sweat of the people on such superfluous things . . . All of this might be conceded to me and approved; but that is not what is at issue here . . . One must not be in the least biased in favor of the existence of the thing, but must be entirely indifferent in this respect in order to play the judge in the matter of taste.[26]

Artworks collected in museums belong to our contemporary world because they can be seen here and now. But at the same time they do not

have their origin in the contemporary world. And they also, and that is even more important, do not have any use inside the contemporary world. There are also other things – for example, urban buildings that have their origin in the past but are used by their inhabitants, and this use integrates them into the contemporary world. However, objects put inside the museum are not used for any practical purposes: they remain there as witnesses of the past. And it is, actually, the essential characteristic of art: art survives its original culture and takes a long journey through all the other, later cultures remaining at the same time foreign to them – remaining an alien in their middle. The museum is the other of our contemporary culture.

It is precisely the otherness of art that makes artworks visible. But here again the line between the same and other, or the artwork and the mere ordinary thing, is shifting all the time. The discovery of ancient Greek and Roman artifacts and manuscripts led to the Renaissance: one began to see the cultural ideal in pre-Christian Greek art – medieval art was, on the contrary, proclaimed to be unaesthetic. But then the Pre-Raphaelites turned social attention back to medieval art and

rejected "Raphaelite" art as being not spiritual enough. They opposed medieval communities to modern technological civilization producing soulless, serial, and trivial objects. And it was then precisely these ordinary objects that were included in museum collections and exhibitions as readymades by artists from Duchamp to Warhol. The history of art is a chain of revivals, rejections, and imitations in the search for otherness. Historical canons are permanently reconsidered: one includes what was formerly excluded and excludes what was formerly included. The institutional museum does not only keep the past in the middle of contemporaneity; it also gives to a present, living generation a perspective of the after-life.

There are basically two ways to deal with this alien status of art. One of them is to discuss the way in which artworks of the past are selected and displayed in our art institutions. Here the focus is shifted from these artworks themselves toward the way in which they are dealt with by contemporary culture. Institutional critique is of course important and useful, but it concentrates on the problems that are characteristic for the contemporary world and ignores the heterogeneous character of art of the past. Then we lose

the possibility of seeing contemporary culture as already dead and musealized – as a particular cultural form among other cultural forms. In other words, to see the face of contemporary culture as a mask by comparing it to the masks inherited from the historical past. We know that we are mortal. But history teaches us that the culture in which we live is also mortal. So we can anticipate the death of our culture as we anticipate our own death. When we look at our culture from the perspective of its origin, we remain immersed in this culture – we cannot see it as a form. But due to anticipation of the death of our culture, we can change our perspective and look not from the past and present toward the future, but from the future toward the present and the past. Then the cultures of the past, including one's own culture, present themselves as a panorama of options from which the subject can choose what suits them. All cultural formations that this panorama includes are defunctionalized. And by being defunctionalized, these formations begin to indicate certain subjective attitudes more than real political or economical conditions.

Of course, it seems that today we function primarily as the knots in networks of information

and communication. In relationship to these networks, our role can be only that of the content providers – voluntary content providers if we actively put some information in circulation or involuntary content providers when we are watched on and analyzed by special services of all kinds. So the act of kenosis does not seem to be possible any more. The erasure of content equals self-erasure. When we switch off our informational function, nothing remains. We can provide only the content – it is the informational apparatus that gives this information a form. And this informational apparatus is obviously hierarchically organized: managed by big corporations, state bureaucracies, etc. So it seems that we have lost the chance to become sovereign master of our images: we can merely be useful. The system of universal slavery seems, indeed, complete.

However, this image of humankind as a network is misleading. We are not connected by informational networks; it is just our computers and mobile phones that are connected by them. Here we are confronted with the same mistake that had already been made in the past when people believed that modern technology would

allow them to move faster. But it was trains and planes that moved fast – not people. On the contrary, instead of walking or riding horses as they did before, in trains and planes people sit immobile in their seats. The same can be said about contemporary informational technology. For a human being who sits alone in front of a computer, the informational flows are external – they present themselves as a spectacle. To understand this spectacle of communication one should see it as what it actually is – namely, as a spectacle of discommunication and miscommunication. In our time, all information is regularly accused of being disinformation. Immediately after its appearance, all news is proclaimed to be fake news. The reaction of users to any content that is posted on the Internet mostly looks totally absurd. When I see this spectacle, I always remember the passage from the First Surrealist manifesto (1922) in which André Breton offers (fictional) examples of conversations between a psychiatrist and his patient. Here they are:

Question: How old are you? Answer: You.
Question: What is your name? Answer: Forty-five houses.[27]

And then Breton writes that usual social communication only conceals similar misunderstandings. He writes further that books are also confronted with misunderstandings of the same kinds – and, especially, by their best and brightest readers. Breton ends this passage by saying that, in the answers he quotes, thought is at its strongest because it rejects being judged according to its age and name. In other words, Breton sees discommunication as the hidden truth of every communication. After all, we are not communicating spirits but discommunicated bodies.

What does it mean to have a body? In his *Being and Nothingness*, Sartre describes the relationship of the human subject to its body as a feeling of shame.[28] One wants to be recognized as a subject – and is ashamed to be seen by others as a mere object, a mere thing among other things of the world. From the phenomenological point of view, this description is problematic. A human is seen not as an ordinary thing, but, rather, as a treacherous, unstable thing – a thing on which one cannot build, cannot rely. As a tool, the human being is not as good as other tools. The human is assumed to have consciousness and, thus, of being treacherous. That is a true reason for the

feeling of shame that Sartre describes. Actually, one is not ashamed to be a thing. One is ashamed to have a consciousness that makes one a bad thing, an unreliable tool.

For a human, becoming an artwork means coming out of slavery, being immunized from violence, not being used as means for the social good, becoming an object of protection. The word *curator* comes from the Latin word *cura*. The curator cares about the health of artworks as a physician cares about the health of humans. Both forms of care are intimately interconnected. The artist – this modern Narcissus – expects care and admiration not only from contemporaries but also from future generations. We are living in a society of expectations, projects, and plans. Our financial system operates primarily with the *futures*. The current value of an artwork depends on expectations concerning its future status. One admires an artwork now because one hopes that it will be admired also in the future. Thus, even if humans are finite and mortal, the care of their public bodies has a potentially infinite perspective. One can expect that these bodies – these public corpses – will be revived in the future. As a rule, under this kind of revival one means

the infusion of old forms by a new content, a new spirit. Living generations cover themselves with masks of the old culture to try to become different – and to make their living conditions different. But the perspective of revival can be radicalized: here, revival means resurrection.

This radicalized notion of revival was conceptualized by Nikolai Fedorov, who believed that all human institutions should become institutions of care and subjected to the goal of achieving immortality for the whole of humankind. Fedorov also asserted that, in our age, in which technology follows the logic of progress understood as the substitution of old things by new ones, only the museum contradicts the utilitarian, pragmatic spirit of modernity.[29] The museum preserves with great care precisely the useless, superfluous things of the past that no longer have any practical use "in real life" – and make these things last, make them immortal. Because each human being is primarily a body among other bodies, a thing among other things, humans can also be blessed with the immortality of the museum. For Fedorov, immortality is not a paradise for human souls but a museum for human bodies. Divine grace is replaced

by curatorial decisions and the technology of museum preservation.

Just as the museum's administration is responsible not only for the general holdings in its collection, but also for the intact state of every given work of art, making certain that individual artworks are subjected to conservation when they threaten to decay, so the state should bear responsibility for the continued life of every individual person. The state can no longer permit itself to allow individuals to die privately or the dead to rest peacefully in their graves. Death's limits must be overcome by the state. Biopower must, indeed, become total. This totality is achieved by equating art and politics, life and technology, the state and the museum, the regular space and the heterospace. This way of overcoming the boundaries between life and death does not lead to the introduction of art into life, but to the transformation of life into art. Human history will become art history – because every human being will become an artwork. And, thus, humans will see their origin not in nature, in the human biology, but in art, in the technology of art.

Fedorov not only criticized technology; he also admired it and believed in its possibilities. Thus

he believed that technology should make the earth more mobile. In his essay "Astronomy and Architecture," written at the end of the nineteenth century, he calls for changing the trajectory of the movement of the earth through the universe. The earth should cease to be a satellite of the sun and should be turned into a cosmic ship that would travel freely – free from the power of gravity – through cosmic space. The energy for this free movement will come from the Sun:

Imagine now that the energy sent to the earth by the sun, which presently scatters off into space, could instead be conducted onto the earth, thanks to a massive configuration of lightning rod aerostats, implements that will drive solar light to our planet. Imagine that this solar energy, once directed earthward, might alter the density of its new home, weaken the bonds of its gravity, giving rise in turn to the possibility of manipulating its celestial course through the heavens, rendering Planet Earth, in effect, a great electric boat ... [I]t (the Earth) will begin sailing the celestial seas, with the sum total of the human race rendered as captain, crew, and maintenance staff of this Earth Ship.[30]

At first glance, the images of museum and ship seem to be very different and even opposing each other. But here one can remember the notion of the heterotopic space coined by Michel Foucault. Foucault applied this notion equally to the museum and to the ship – according to Foucault both are the heterotopic spaces in which time accumulates.[31]

9

The Fedorovian project of the musealization of all living and dead human bodies with the goal of their resurrection seems to be fantastic – but, in fact, it only reveals the ontological dimension of the modern museum and, more generally, modern cultural system. This system is based on the promise of revival of past cultural forms. In the absence of such a system, history – the flow of things, the movement of time – would seem irreversible, fateful. The museum system offers a possibility of reversal, of revolution – a return to the previous state of affairs and a new beginning that would change the course of history. However, such a renaissance of the old cultural forms is possible primarily due to the relative

similarity of organic human bodies throughout the whole of human history – bodies involved in the repetitive circle of birth, life, and death. Even if lifestyles and cultures have historically changed, the basic characteristics of the human body have remained relatively stable. The stability of the human body allows cultural forms of past epochs to be enlivened and energized, by using them as masks and costumes for contemporary living bodies. It is this transhistorical stability of the human body that constitutes the horizon of the Fedorovian project – the project of the resurrection of past generations.

Traditionally, the forms and objects of cultural memory were considered as passive, lifeless. To bring them back to life, to make them active, a human body and its life energy were needed. However, during the period of modernity the situation has changed. Not merely forms of life but the energy of life began to be reproduced, copied. Today, electricity is used not just as a medium of communication with the digital souls of the dead, but as the energy that compels "thinking machines" to think and robots to work. This use of electricity is at the heart of different projects of post-humanism and transhumanism, in

which electricity is treated as the new form of life energy. Let us put aside the question of the practical realizability of these projects and concentrate on the ontology that they presuppose. In a very premodern way, these projects see humans as combinations of spirit and body and assume that when one substitutes the organic human body with a machine, and the spirit with electricity, one gets something like a better, improved, more reliable humanlike being. The body of thinking machines is a combination of hardware and software. When hardware is activated by electricity, software is activated too. Transhumanism is based on a belief that the human nerve system is analogous to computer software and that a particular software can be rewritten without any losses from one hardware on the other. In this respect, transhumanism is a contemporary version of the old, good metempsychosis – animal bodies being substituted by the computer's hardware.

Today, one assumes that thinking machines are in a certain way "like humans" because humans also "think." But do they? Of course, yes – from time to time. However, in humans the process of thinking is subjected to the will of survival and fear of death. The human spirit does not only

live – it will live, it has a desire to survive. That is why, as Kojève describes it, the thinking process becomes interrupted time and again by hunger, thirst, and other bodily needs. When the "spirit" does not subject its thinking to the needs of the organic body, the human dies. Then the organic body begins to decompose and thus ceases to be a potential vehicle of the spirit. Only the public corpse remains, and that can be brought back to life by subsequent generations. The organic body has autonomous "life energy." When the organic body dies, its life energy disappears.

However, when a thinking machine is switched off from the networks of electric supply, nothing happens to its body – be it hardware or software – and nothing happens to the electric energy. This body remains intact and can be switched on again at any moment. One can say that for thinking machines their organic bodies and public bodies coincide. And that means that thinking machines can copy neither the forms of human thinking nor the modes of human action. Human thinking and acting are determined by the care of human individuals for their survival – for keeping their life energy and preventing their bodies from dying or decomposing. Thinking machines,

however, do not care about the influx of electricity because they don't have to – humans do it for them. But even if the influx of energy is switched off, these machines do not die. Their hardware and software remain intact – just waiting for the next activation. Thus, it is not the machines themselves, but only humans, that are interested in their functioning. Humans care about thinking machines as they care about all their other tools. Some novelists imagine a revolt of thinking machines against exploitation by humans. They compare machines to human slaves. But this analogy is wrong. Slave work uses the living energy of the slaves' bodies – and ruins those bodies. So the revolt of the slaves is understandable – they want to protect their bodies from ruin. But exploitation of the machines does not ruin their bodies and, thus, a revolt against this exploitation makes no sense. On the contrary, machines get their energy – electricity – only when they are working. Thinking machines begin to think when they are switched on and cease to think when they are switched off. The problem with AI is not that it is embodied by the machine substituting an organic body, but that it is activated by artificially produced energy. And electric energy is not an

exact copy of life energy. Indeed, if electricity runs through a living human body, the body dies. The energy that lets the thinking machines think is the energy that kills people. Of course, one can imagine that a thinking machine begins to worry about the supply of electricity. In Stanley Kubrick's movie *2001: A Space Odyssey*, the main computer, HAL, started to worry about the possibility of being switched off and at this moment became somewhat human – violent, intriguing, murderous.

One can easily imagine a struggle for the supply of electricity among thinking machines – analogous to human fights for food and water. Indeed, electricity is by no means "immaterial" and thus infinite. The amount of electrical energy produced globally is limited. If thinking machines begin to fight for these limited resources, they start to resemble humans. But it is questionable whether thinking machines would prefer working to non-working, or, for that matter, thinking to non-thinking. Buddhists believe that the human spirit manifests itself not in thinking but in non-thinking. In the case of thinking machines, their bodies, obviously, manifest themselves better under conditions of

non-acting and non-thinking. To really investigate the machine's body, one has to switch this machine off – otherwise one will be electrocuted.

Thinking machines have an enemy – but it is not the scarcity of energy. It is technological progress. By its very definition, technology is moving forward, progressing, becoming better. As we have already seen, progress means substitution of old tools by new tools. And that means that old thinking machines will inevitably be substituted by new thinking machines that presumably will think better. The old, obsolete machines will be destroyed. And, because their organic bodies coincide with their public bodies, these machines will be completely destroyed. The technological past will not be preserved because it will be considered not as different, but as worse than the present. Humans reproduce themselves. The reproductive character of organic human bodies compensates for the destructive work of progress and makes the human past relevant for the human present, and the human present relevant for the human future. The transhuman progress, even if it is possible, can be only self-destructive.

That is also true for projects of a symbiosis between man and machine. The goal of this

symbiosis is, obviously, the improvement of human abilities and skills. Earlier, race theory saw the possibility of improving humankind by means of social selection. Today, one hopes to achieve the same goal by technical means. Obviously that will lead to a new radical form of inequality, which will not merely be the external inequality of income but will become inscribed directly into human bodies – some of them acquiring abilities that the other bodies would lack. In other words, we see here an attempt of a return to the feudal order under the use of contemporary technical means. Cyborg culture promises some kind of a neo-feudal condition. But, actually, it will not escape progress. That means that all cyborgs will be discarded almost immediately after they have been produced. Previous generations will not offer forms that could be appropriated by later generations. Here again, the comparison between past and present will become impossible. Post-humankind will look like a cabinet of curiosities – or, rather, monstrosities.

In his *Accursed Share*, Georges Bataille describes biological evolution as the growth of death. He writes: "As we know, death is not necessary. The simple forms of life are immortal: The birth of an organism reproduced through scissiparity is lost in the mists of time."[32] Biological evolution makes the organism more and more endangered by death while at the same time becoming the tool of death:

In this respect, the wild beast is at the summit: Its continual depredations of depredators represent an immense squandering of energy. William Blake asked the tiger: "In what distant deeps or skies burned the fire of thine eyes?" What struck him in

this way was the cruel pressure, at the limits of possibility, the tiger's immense power of consumption of life.[33]

Now we should say that the cultural evolution plays a similar role in relationship to afterlife.

Also in our time, the Egyptian pyramids manifest the strongest testament to the afterlife. Even today they seem indestructible. The life of an Egyptian noble was governed by preparation for his mummification, by the production of his final public corpse. Indeed, the process of mummification starts by removing the brain through the nose and all other internal organs through a special cut at the left side of the body. Thus, the body becomes a pure form. In other words, the process of mummification is analogous to the psychological process of kenosis. So it is not surprising that Jan Assmann characterizes ancient Egyptian funeral rites, including mummification, as an expression of Egyptian culture's preference for social life. Indeed, he quotes the Egyptian "satires of the trade" that describe life as a place of loneliness:

The unkind, derisive glance that the satires on the trades cast on these occupations isolates the

exercise of them from the structure of meaning inherent in social activity and represents them as lonesome ones, absurd à la Sisyphus or Beckett in the circular nature of their activity: the fisherman fishes, the washer washes, the barber barbers, with nothing whatsoever resulting from all this labor except that in the end, they are worn out, wet, and dirty, and no one wants to have anything at all to do with them . . . What they view as the worst evil are the concepts of isolation, loneliness, self-sufficiency, and independence.[34]

It is death that opens the way to social life. To the image of loneliness,

there corresponds the counterimage of acceptance of the deceased into the world beyond and his complete, heartfelt inclusion in the social constellations of the afterlife. Thus, in the Egyptian texts, the world beyond is not a spatially conceived landscape but rather a social sphere that needs to integrate the deceased into itself as a newcomer.[35]

The deceased is celebrated:

The appearance of the deceased as king and ruler of those in the netherworld is the exact reversal not

only of isolation but also of his loss of honor and status as a result of death. It is for this reason that praise of the deceased plays so important a role . . . In the mortuary texts of the New Kingdom, however, the deceased turns to the inhabitants of the realm of the dead as peers and expresses the wish that he be accepted into their circle as one of them.[36]

Here it is important to see that, for ancient Egyptian tradition,

the essential distinction within the totality of a person was not that between the body and the soul, but that between the individual self and the social self. The "souls" of this individual, or bodily, self included the *ba* and the shadow, while the social self was comprised of the *ka* and the name . . . At birth, life was just a possibility, one that was actualized only when the social self was developed through a process of socialization. "Life" was thus more a matter of culture than of nature. It was in this respect that the Egyptians viewed the possibility of prolonging life beyond its biological limitations through cultural effort.[37]

The deceased was understood not as a soul exiled into the "other world" but as a social body – manifested as a pyramid, present in the middle of actual social life.

This transition from the biologically determined *ba* to the socially, culturally determined *ka* is characteristic not only for Egyptian culture. The prominent example of the same transition is offered by Jeremy Bentham's *Auto-Icon*. Bentham outlined his design for the *Auto-Icon* in a will written shortly before his death in 1832. According to the will, his body was to be mummified, dressed in his usual clothes, and placed in the chair in which he usually sat when he was speaking to colleagues and students. The room in which *Auto-Icon* was installed was intended to serve as a place for regular meetings by students and disciples, as Bentham writes, "for the purpose of commemorating the founder of the greatest happiness system of morals and legislation."[38] Bentham even carried a set of glass eyes with him in case of his sudden death. All these instructions were honored, and the Bentham mummy can still be seen seated in a special case at University College London. However, Bentham's head suffered damage during the desiccation process

and is stored separately; the head of the seated mummy is made of wax.

An undoubted masterpiece of the Russian avant-garde, the Lenin Mausoleum on Moscow's Red Square, is based on the same principle. The Lenin Mausoleum has often been compared to the Egyptian pyramids and the vaults containing the relics of saints. It is obvious, however, that the Mausoleum makes one decisive step further in socializing *ka*. The pyramids concealed the mummies of the pharaohs, as well as the holy relics that were inaccessible to ordinary mortals. The mummies were displayed for the first time in European museums after Europeans looted the Egyptian tombs. The holy relics became visible as a result of the atheistic revolution. Lenin's body, on the other hand, was intended from the outset to be viewed by the general public. In other words, the Mausoleum was originally planned as a combination of a pyramid and a museum – as a sacred site that had been desacralized and socialized from its inception. But what matters most is that the Egyptian mummy is the end product of special procedures performed on the body of the deceased. The mummy of the pharaoh does not resemble his body as it was in

life, but this is exactly what Lenin's body does in the Mausoleum. Lenin's body seems to have been taken directly from life. It is essentially a readymade. Indeed, Lenin's body was not subjected to any artistic intervention, any ritual or religious transformation. Thus, the avant-garde's main requirement – no artiness, no aesthetically dictated distortion of the facts – was strictly observed.

But the Mausoleum has its own secret. Egyptian mummies were protected from decay by the transformation they underwent before burial. Lenin's body was and has been the object of constant care by an entire scientific institute that monitors its integrity and maintains it in a stable, exhibitable condition. Lenin's body in the Mausoleum differs from Bentham's mummy in that it is not a mummy in the full sense of the word, and therefore cannot exist independently of the technology that supports its continuous mummification. The mausoleum is a unique monument not only to radical atheism, but also to the modern human body's irreversible integration into the industrial process. Care for an individual *ka* becomes a social, collective task.

The same can be said about museums and libraries. In a museum, library, or university, we are confronted with the *ka* of dead authors – and begin to communicate with them. As has already been said, the *ka* is empty – as a mummy is empty. The narcissistic desire that produces art and writing presupposes the emptying, the kenosis, of an individual – already turning this individual during their lifetime into a pure, empty form. The artist or writer transcends their time precisely because they practice this self-emptying. Malevich said that his art was based on nothingness; Duchamp compared himself with Buddha. Of course, it is easy to say that this act of kenosis is illusionary and to resituate the artists or writers in their original time and space – to reframe them using their biographical data, historical chronicles, etc. However, an opposite strategy seems to be more promising: to situate oneself inside these empty forms – to revive these forms. It is this strategy that moved modern history, which was basically the history of revivals. The contemporary politic of identity would be impossible without the politic of revivals. These revivals change the hierarchies in the realm of the dead. The valued forms begin to be

devaluated – and the overlooked forms begin to be revaluated. These revaluations of the values constitute the permanent communication with the dead that affects their *ka* as much as it does our living bodies.

In all these cases it is crucially important that the revived forms were originally sufficiently emptied – radically detached from their original local content. Only in this case can they be filled later by other content. But here a question is still possible: why does one need a revival of old forms and not an invention of new forms to change society? The answer is easy to give: to change oneself or society, one needs to exit this society, to find a meta-position in relationship to it from which the change would become possible. Every form that is invented here and now belongs to contemporaneity – even if this form is projected into the future. That means that only the past can offer a collection of the empty meta-forms that can be filled by the new content. Today, one often speaks about cultural differences of different kinds. But, actually, we all are living in the same global culture using the same means of transportation and communication, the same financial operations, the same medicine, the same

type of housing, etc. When we speak about racial, gender, and cultural identities, we actually speak about our relationship to the past – to the already dead people who had the same race, gender, and cultural identity. It is this specific relationship to the past that makes one different from the others who live in the same contemporaneity, but have a different past.

In fact, our own civilization includes the dead and blurs the difference between living and dead to a much greater degree than the ancient Egyptian civilization. When we go to a museum or a library, we do not always know if a book or an image that we find there was produced by a living or a dead author. At the moment at which a book is published or an image is exhibited, they become dissociated from the living bodies of their authors and become parts of their public bodies or, rather, corpses – of their *ka*. An author is always a dead author – without acquiring any additional information, one cannot differentiate between living and dead "content providers." The recording in "real time" kills the recorded person in the middle of their speech or action because such a recording simultaneously transforms the elements of living *ba* into the components of

the social *ka*. The Internet, to an even greater degree than traditional museums and libraries, mixes the *ka* of the living and the dead in the same space.

That shows that every culture produces a specific type of afterlife, of immortality. It is not necessarily a type of immortality that one has in mind when one speaks about the desire of personal immortality. It is easy to say that the Pharaohs desired immortality for their *ka* – and their pyramids are the manifestations of this desire. But it is equally possible to say that a Pharaoh was involved in the production of *ka* in the same way that we can be involved in the production of computers or cars. The analysis of the actual production of immortality should be dissociated from the discussion concerning the desire of immortality, the desire for afterlife. The production of afterlife is a process that takes place independently of our interests or desires. Whatever our desires are, our lives become recorded and, thus, our public bodies become produced. In many cases the way in which this production functions is unpleasant to us and even insults us. So the problem is not immortality as such, but a way in which immortality

happens to us, what kind of immortality we want and how we try to take control of the production of afterlife.

Narcissistic desire seems to coincide with the desire for immortality – with the desire to influence the production of immortality. When I sacrifice my "biological" desires to my image that does not belong to me but to the others – and can be seen by me only if being mediated by the external world – I sacrifice my living, mortal body to my public body, to my *ka* that exists independently of me and, thus, will not disappear with my death. However, living in a certain culture I am subjected to the mechanisms of immortalization by which this culture operates. And, as we have seen, all cultures have their own specific mechanisms of immortalization that an individual cannot escape. Immortality is always imposed on me – even when I want to avoid it.

Our civilization is based on the ideal of technological progress. Technology is mostly understood as technology of production and the progress of technology – as production of new products. However, improvements to the mechanisms of care, protection, restoration, and maintenance of the already existing products are also part of

technological progress. It is important to see the difference between technologies of production and technologies of care. The process of production always has a definite goal – the emergence of the product. When the product is produced, the process of its production finds its end. Thus, production is always a finite process. The productive process begins with a plan – and ends when this plan is realized. It begins with the absence of the product – and ends with its presence.

However, the trajectory of care is a different one. It starts with the presence of an object of care – and tries to prevent its disappearance. Thus, the technology of care has a relationship to time that is opposite to the technology of production. For the technology of production the future is a promise – a promise of realization of the plan, of the appearance of the product. For the technology of care the future is a danger that it tries to avoid. Here the power of time is experienced as a power of destruction, dissolution, and decay – to which the work of care tries to resist. That means that every work of care has, not future, but timelessness, eternity, as its actual horizon. And timelessness is the same as immortality.

Of course, every work of care is also finite.

One cares about a human body – but at some point this human body dies. One cares about a car – but at some point it becomes used and broken beyond repair. However, if the end of the production process coincides with its goal, the end of the care process contradicts this goal. Death is not the goal of medical care. The care is merely interrupted by death – but not fulfilled by it. The same can be said about the repair of a car – there is no goal to make this car totally broken. In other words, the work of care has immortality of the object of care as its actual goal. Can one say that this goal will be never achieved? In fact, it is an open question. Modern archive and museum technology has a goal to keep some art objects and documents forever. But protection of the natural environment, different animals, plants, and so on has the same goal. These ecological politics and technologies are designed to keep the nature as it is forever – for all eternity.

Now the strategies of care, protection, and immortalization are closely connected to the strategies of aesthetization. When we see something that we recognize as beautiful, we want to keep open the possibility of coming back to this contemplation in the future – and that presupposes

that the object of contemplation will be taken care of and protected forever. Of course, in the best case the object of contemplation is eternal in itself – such as Platonic ideas, God, or mathematical evidences. The beautiful waterfall, bird, poem, or painting, though, can disappear when they are not technologically protected. Here technology substitutes ontology. What we call culture is nothing other than this substitution.

When a human is confronted with his or her public image, they find this fascinating and traumatic at the same time. The subject becomes confronted with his social afterlife in the middle of his biological life. And it is precisely what happened to Narcissus: he saw his own public image and did not know how long this image would last – for only a moment or for eternity. It is the situation in which we permanently find ourselves today. However, if the cultural guarantee of immortality is given technologically and not ontologically, the immortality of an individual is dependent on the immortality of mankind as such. The Egyptian pyramids were built in a way that they did not need any additional care to remain a part of a landscape of Earth. In other words, these pyramids did not need the further

existence of humankind – not children and grandchildren, not collective memories. This is the main source of fascination that the Egyptian pyramids exert. They demonstrate to spectators that they do not need them – like the sky, or the mountains, or the ocean do not need humankind to further exist. In this respect, ancient Egypt is superior to almost all other post-Egyptian cultures that, to a much greater degree, rely on the care and maintenance of future generations. Books, paintings, photographs, and films are less reliable bearers of individual *ka* than even Greek and Roman sculptures. But the contemporary Internet completely depends on the supply of electricity that, in its turn, depends on humanity as a stable source of renewable energy.

The problem with the contemporary *ka* is not only the lack of reliable material support. The public corpse of an ancient Egyptian kept its unity and had a unique place – a tomb, a pyramid. Modern and contemporary public corpses are fragmented and dispersed. An *œuvre* of an artist is, as a rule, distributed through different collections and museums. The writings of a writer are also most often distributed through different archives. But in our time this decentering

of an individual *ka* became extreme through the Internet. When one searches a particular name on Google, one gets thousands of references and it is impossible to go through them all to construct a complete image of a person with that name. Here the user – and, actually, the whole of humanity understood as a society of users – acts as Isis, who tried to collect all the fragments of Osiris' body. One knows that even Isis failed in that task and had to substitute the original living member of Osiris with an artificial one – thus initiating the chain of simulacra, fake news, and false identities that plague human communication up to our own time. Of course, one can hope that the general intellect of humanity will be more successful than Isis. But this hope only indicates that the time of our afterlife depends on our children and grandchildren more than on the ability of an individual to create a public corpse the existence of which will be independent from the human work of care.

And here again, from the beginning my public image does not belong to me – it is not a part of my world. It belongs to others – it is a part of their world. To admire my own image means to value the world of others more than my own

world, to privilege the gaze of others over my own gaze. In other words, it means practicing self-emptying, or kenosis, with the goal of becoming a pure form in the world of others. Bentham made the real point when he called his posthumous image the *Auto-Icon*. The Christian icon presents a visual form of the invisible. The body of Christ is merely an incarnation, one can say a simulacrum of the invisible God. One can accept this incarnation as "real" only through an act of faith – because one cannot compare the visible with the invisible and thus establish whether an icon corresponds to the true image of God or not. Now, I am also invisible to myself. And thus I cannot be sure that my selfie truly presents "me." This selfie remains forever only an *auto-icon* that I can recognize as "my image" only through an act of faith. In other words, I can join humanity only through an act of faith – through a leap over the ontological gap that divides my gaze from the gaze of the others.

Thus, our narcissistic desire still relies on a certain kind of religion – even if this religion is a religion of humanity. "The religion of humanity" was proposed by Auguste Comte in 1851 in his book *System of Positive Polity* with the subtitle *Treatise*

on Sociology Instituting the Religion of Humanity.
Comte writes that the religion of humanity can
be considered as the only true religion because it
implies veneration of something that undeniably
exists. And humanity only truly exists because
the human individual is human only as a part of
humanity. But if the actual existence of humanity
here and now is a fact, its existence in the future is
a matter of faith, of social myth. This social myth,
this secular religion, is necessary for our actions
because if we do not believe that humanity will
continue to exist, all our own plans and projects
will lose their horizon of realizability. However,
this faith relies not on the facts but only on social
sentiment. According to Comte, human society
is based ultimately on the power of gravity that
keeps people together on the same piece of the
earth's surface.[39] However, the forces of gravity
cannot prevent a cosmic catastrophe that could
destroy humanity in its entirety. Anticipation of
such a possibility, Comte says, makes the reli-
gion of humanity even more intense. We might
say more intense and thus more religious. We
know that when we die we leave a corpse that
will decompose and dissolve in the earth. But
we can also expect that our skeletons will keep

their form for a very long time – without any human care and intervention. Our public corpses remind us of skeletons: they also seem to be more stable than our flesh. However, they are much more endangered: monuments can be removed and destroyed, books discarded and even burned. And digital souls can be switched off. It can happen, though, that these public corpses remain intact – for this or that reason or by pure accident. In this case, we would prefer these corpses to be designed according to our taste – so that we can look at them with pleasure, as Narcissus looked at his reflection in the lake.

Notes

1 Jacques Lacan, "The Mirror Stage as Formative for the I Function," in *Écrits* (New York: W.W. Norton, 2006), p. 76.

2 Alexandre Kojève, *Introduction to the Reading of Hegel: Lectures on the Phenomenology of Spirit*, ed. Allan Bloom, trans. James H. Nichols (Ithaca, NY: Cornell University Press, 1980), pp. 3–4.

3 Kojève, *Introduction to the Reading of Hegel*, p. 6.

4 Kojève, *Introduction to the Reading of Hegel*, pp. 6–7.

5 Marcel Mauss, *The Gift: The Form and Reason for Exchange in Archaic Societies* (New York: W.W. Norton, 2000).

6 *Hegel's Phenomenology of the Spirit* (Oxford: Oxford University Press, 1977), p. 362.

7 *Hegel's Phenomenology of the Spirit*, p. 194.

8 Siegfried Kracauer, "Photography," in *The Mass Ornament: Weimar Essays*, trans. and ed. Thomas Y.

Levin (Cambridge, MA: Harvard University Press, 1995), pp. 56–57.

9 Roland Barthes, *Camera Lucida*: *Reflections on Photography* (New York: Hill and Wang, 1980), p. 65f.

10 G.W.F. Hegel, *Elements of the Philosophy of Right* (Cambridge: Cambridge University Press, 1991), p. 226.

11 Friedrich Georg Jünger, *The Failure of Technology. Perfection without Purpose* (Independently Published, 2021), p. 115.

12 Annie Besant and C.V. Leadbeater, *Thought Forms* (Wheaton, IL: Quest Books, 1999), p. 17.

13 Adolf Loos, *Ornament and Crime* (1908), in *Ornament and Crime: Selected Essays*, ed. Adolf Opel, trans. Michael Mitchell (Riverside, CA: Ariadne Press, 1998), p. 174.

14 Loos, *Ornament and Crime*, p. 168.

15 Alexei Gan, "Constructivism," in Charles Harrison and Paul Wood, eds., *Art in Theory, 1900–1990: An Anthology of Changing Ideas* (Oxford: Blackwell, 1993), p. 320.

16 Adolf Loos, *The Poor Little Rich Man*, in August Sarnitz, *Adolf Loos, 1870–1933: Architect, Cultural Critic, Dandy*, trans. Latido (Cologne: Taschen, 2003), p. 21.

17 Ernst Jünger, *The Worker. Dominion and Form* (Evanston, IL: Northwestern University Press, 2017), p. 82.

18 Jünger, *The Worker*, p. 82.

19 Guy Debord, *The Society of the Spectacle*, trans. Donald Nicholson-Smith (Princeton, NJ: Zone Books, 1994).

20 Cited in Boris Groys, *The Total Art of Stalinism. Avant-Garde, Aesthetic Dictatorship and Beyond* (London: Verso, 2011), pp. 95–96.

21 Maurice Merleau-Ponty, *The Visible and The Invisible* (Evanston, IL: Northwestern University Press, 1968), p. 123.

22 Oscar Wilde, "Poems in Prose," *The Fortnightly Review* (July 1894), p. 22–29.

23 Michel Foucault, *"Society Must Be Defended": Lectures at the College de France, 1975–1976* (New York: Picador, 2003), pp. 241ff.

24 Jean Baudrillard, *Symbolic Exchange and Death* (Thousand Oaks, CA: SAGE, 1993), pp. 125ff.

25 Søren Kierkegaard, *Fear and Trembling*, trans. Alastair Hannay (London: Penguin, 1995).

26 Immanuel Kant, *Critique of the Power of Judgment*, ed. Paul Guyer, trans. Paul Guyer and Eric Matthews (Cambridge: Cambridge University Press, 2000), p. 90.

27 André Breton, *Manifestoes of Surrealism* (Ann Arbor: University of Michigan Press, 1969), p. 34.

28 Jean-Paul Sartre, *Being and Nothingness* (New York: Washington Square Press, 1993), pp. 222f.

29 Nikolai Fedorov, *The Museum, Its Point and Purpose*, in *Avant-Garde Museology*, ed. Arseny Zhilyaev (Minneapolis: University of Minnesota Press, 2015), pp. 815–834.

30 Nikolai Fedorov, *Astronomy and Architecture*, in *Russian Cosmism*, ed. Boris Groys (Boston, MA: MIT Press, 2018), p. 56.

31 Michel Foucault, *Of Other Spaces: Utopias and*

Heterotopias, trans. Jay Miskowiec. *Architecture, Mouvement, Continuité* (October 1984).

32 Georges Bataille, *The Accursed Share: An Essay on General Economy*, vol. I (Princeton, NJ: Zone Books, 1988), p. 32.

33 Bataille, *The Accursed Share*, p. 34.

34 Jan Assmann, *Death and Salvation in Ancient Egypt* (New York: Cornell University Press, 2005), p. 57.

35 Assmann, *Death and Salvation in Ancient Egypt*, p. 58.

36 Assmann, *Death and Salvation in Ancient Egypt*, p. 58.

37 Assmann, *Death and Salvation in Ancient Egypt*, p. 15.

38 https://www.britannica.com/story/what-is-jeremy-benthams-auto-icon.

39 Auguste Comte, *System of Positive Polity: General View of Positivism and Introductory Principles*, trans. John Henry Bridges (London: Longmans, Green and Co., 1875), pp. 408f.